Teaching Drawing from Art

Guernica Horses

Teaching Drawing from Art

Brent Wilson
Al Hurwitz
Marjorie Wilson

Davis Publications, Inc.
Worcester, Massachusetts

Printed in the United States of America

*Library of Congress Catalog Card
Number:* 86-72605

ISBN: 0-87192-188-X

Graphic Design:
Penny Darras-Maxwell

Front Cover:
(Above) Pablo Picasso. *Guernica,* 1937.
Oil on canvas, 3.5 × 7.76m.
Prado Museum, Madrid. Copyright
ARS, NY/Spadem 1987.
(Below) Student drawing inspired
by *Guernica.* See also p. 147.

Back Cover:
Drawings inspired by *Guernica*
are by Alexandra Sullivan, age 6.

10 9 8 7 6 5 4 3 2 1

Contents

Preface

Our culturally and theoretically supported valuing of individual uniqueness and creativity have possibly led to an exaggeration of the distance between copying and inventing.—Edna Shapiro

One of the basic premises of this book on drawing for the schools is that works of art provide the basic models from which drawings are made. In short, art comes from art; drawing comes from drawing.

In spite of ourselves, we are all creatures of particular artistic and aesthetic societies—the society of child art, for example, or of the art of record covers, of comics. In this book, we suggest that children be made members of another artistic society, the richest and most important of all: the society of art to be found in art museums and galleries. Intimate association with the greatest creative models to be found in the visual arts can enhance students' individuality, originality and inventiveness.

This book sets forth two distinct goals for school drawing programs. First, the development of drawing skills and the power of graphic creation, and second, the development of insights into art through a studio process of re-creation. Some teachers may value one or the other of these goals; others may value both. We value both!

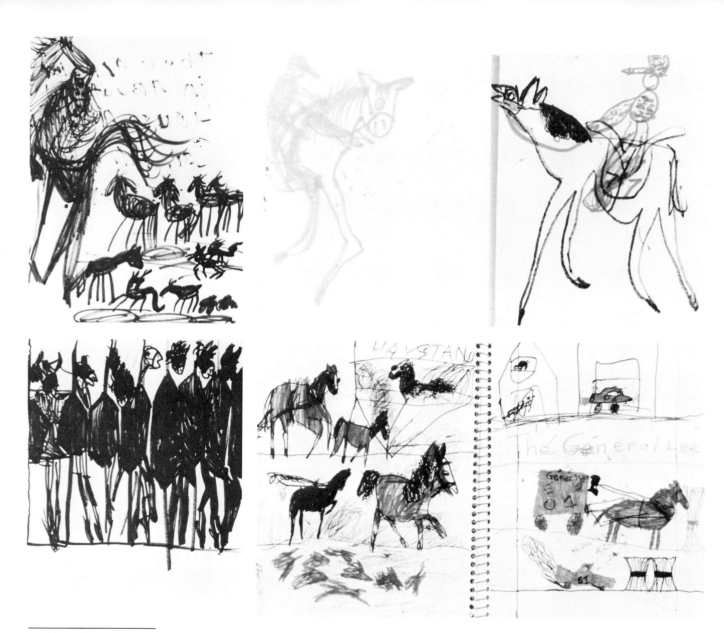

Children, like artists, draw for many reasons. While drawing by herself at home, Lois, at the ages of 7 and 8, populated an entire world with thousands of horses (two hundred pages full of them in one holiday weekend). These exquisitely animated horses won races, had families, lived in houses, didn't have to eat school lunches (unless they wanted to), told jokes and had adventures in their cars.

The psychologist might explain Lois's behavior by saying that she was attempting to achieve through her drawings all the things that she had difficulty achieving in her everyday life. The connoisseur might claim that Lois was cre-

ating a collection of beautiful things. The art teacher might say that she was expressing herself, or that she was intent upon developing her artistic skills. The sociologist might say that Lois was merely reflecting the themes found in television programs. Lois would probably say that she was just having fun.

Actually, there might be dozens of plausible explanations for her drawing. But whatever else Lois was doing, she was incidentally creating a rather complete working model of a world, one in which she could try out all sorts of interesting ideas, and learn all kinds of important things.

The incidental and perhaps even

accidental world-making in Lois's drawings should be built deliberately into school drawing lessons. In their drawing at home, children are free to rely upon ideas from the popular media. School drawings, on the other hand, should reflect the rich content and aesthetic qualities found in works produced by artists.

Teachers ought to discover children in the classrooms who, like Lois, produce mountains of drawing; everything possible should be done to encourage their spontaneous art making activities.

Why Draw? Why Drawing?: The Re-creation of the Worlds of Art

Whatever he [Picasso] wishes to own he can acquire it by drawing it. The truth has become a little like the fable of Midas. Whatever Midas touched, turned to gold. Whatever Picasso puts a line round, can become his.—John Berger

We Draw for Many Different Reasons

Drawing pictures is something that almost everybody does at one time or another. And there are hundreds of motives, both private and public, for making drawings—many more reasons, perhaps, than those who draw might themselves ever be able to explain. Artists, amateurs, young people and children sometimes draw because:

Like Picasso they are able to possess symbolically anything they wish. They are able, for example, to be somebody else, somewhere else, in some other time; they are able to possess riches, have adventures, create and destroy worlds.

Through drawing they have a superb way to express an idea, a feeling or an emotion.

Drawing is fun; it gives pleasure; it's a form of play—a unique one because it leaves a graphic record of all the playing.

They are in awe of the things that they can create (some are amazed that they can draw things as they appear in the world, and others are amazed that they can invent things that could never be).

They see others drawing and decide to try it themselves.

Through their drawing they discover that they are able to amuse themselves, relieve boredom, provide excitement, create and release tensions.

They are able to create an interesting aesthetic effect or to make something beautiful.

They wish to master a technique, a medium, a process.

They are trying to develop greater representational, or expressive skills.

They are important in their own eyes for having created such things.

They are important in other people's eyes for having created such things.

Through their drawings they are able to make money.

They have such a passion or a compulsion for drawing that they cannot stop.

They like to tell stories, and through drawing they are able to create characters, place them in settings, and show what happens, what happens next, and how things finally turn out.

They make drawings as preliminary plans for other works of art such as paintings and sculpture.

They wish to make a record of the things they have seen, and of the experiences they have had.

And the list goes on.

Of course, we are individually free to make drawings for almost any reason, or for no conscious reason at all. Whether we make drawings for a variety of entirely admirable purposes or for purposes that are absurd, that is our affair.

However compelling the personal reasons for drawing, most of those listed above are not sufficiently compelling to justify a place for drawing in the schools. In a time of educational accountability and back-to-the-basics sentiments, can you imagine telling parents that we have drawing in school because it is fun to do; or so that children will not be bored; so that the drawings they create can serve as symbolic substitutes for the things that children desire yet cannot possess; or so that they might gain recognition, fame and money. Even to have drawing in schools because it is presumed to encourage creativity, self-expression or self-discipline seems not to be entirely justifiable inasmuch as the same might be claimed for other school subjects as well.

Reasons Drawing Should Be Taught in Schools

Schools teach what society considers important. If drawing is to be taught as a part of an art educational program, it must be for educationally justifiable reasons.

Drawing has an important place in schools because of its contribution to students' cognitive processes, to their competence and skill in the use of a valuable symbol system. School drawing should promote

the acquisition of knowledge and understanding through a special visual means pervaded with feeling and aesthetic qualities.

And just what can be learned from and through drawing? Drawings and other works of art are like windows-on-the-world. Through them we see and create visions of ourselves and our universes, our concerns, dreams, emotions, our sense of beauty and quality. Although the child and the artist may not set out to create fresh ideas about the world in their drawings, new and expanded world-views are the inevitable result. The often accidental, happy by-product of drawing is the creation of insights that artists may not themselves have sought.

School drawing programs, however, cannot rely on the production of knowledge and fresh world-views that come about purely by chance. School drawing programs must consciously pursue ideas about the world in order to expand conceptions of the world through the creation and *re*-creation of artistic knowledge.

Sometimes school art programs destroy the very things that they were established to encourage. Vladimir, a 10-year-old immigrant from Russia, spent many hours, as did Lois, drawing marvelous battles filled with the most exquisite actions of horses and soldiers. Could there be a better candidate for a special class for children gifted in art? And yet when Vladimir was placed in the special art class and required to complete academic drawing exercises, his interest in drawing declined. Stimulating activity was transformed into boring drudgery. Art teachers need to be aware of and to encourage the spontaneous worlds of drawing of their students; they ought not to be overly concerned about making close connections between school art projects and students' spontaneous art.

Worlds That Our Students Should Make Through Their Drawings

Students should be concerned with creating models of the world through drawing. But how does one do this?

The worlds we create with symbols are probably never made from scratch but rather, according to Nelson Goodman, from worlds at hand. The worlds that we have students create through their drawings will relate to ideas about the world already created through art, whether child art, adolescent art or the art of artists. Consequently, all the world views created by students in art classes will in some ways be *re*-creations, that is to say, extensions, recombinations, modifications and reactions to those already created.

Just what kinds of worlds should our students be re-creating through their school art? In the past, some art educators have said that the world directly experienced by the child should be the source of child art. They believed that children should draw, paint, construct and print their own experiences of going to school, eating, feeding animals—the somewhat romantic ideas of what childhood is about. In their spontaneous drawings, however, young people have shown their worlds to be far broader than that of direct experience; in these drawings children whose everyday world is confined to home, school and playground

Marino Marini, *Acrobats and Horses.* Color Lithograph, 1952, 22 ¼" X 17" Fogg Museum, Harvard University. When students were asked to draw from a description of this Marini lithograph, the sensory qualities of light and dark, the qualities of line, and the textural aspects were as important to the description as the literal figures and their placement.

Why are these drawings by college students, who are not art majors, so qualitatively exciting? The students drew while the instructor described in minute detail the features of Marini's *Acrobats*. The students never saw the lithograph until after finishing their drawings. (Chapter 13 provides a full description of this process of working from verbal descriptions of works of art.)

The work of this important Italian artist acquainted the students with the theme of "horse and rider." They experienced the relationship between the upward thrust of the horses' heads and that of the arms of the riders; they saw how drawings become richer and more expressive through the interplay of built-up linear and light and dark areas. (The instructor emphasized each of these points both during and after the exercise.)

School drawings should reflect students' interpretations of the themes, subjects, ideas, expressive qualities, compositions, techniques and processes that artists use in their work. School programs based on works of art ensure that students come in contact with some of the essential ideas and problems of art. More importantly, through a parallel creation of art, they will encounter the major insights that individual artists have revealed about the world.

have already created and destroyed a universe or two. Through drawing, young people, regardless of age, can in fact deal with important aspects of the world—the patterns and outlines of which have already been set forth by artists.

Yes, artists explore the world of everyday experience. Andrew Wyeth and Edward Hopper have shown us that, and their views can enrich the young person's drawing of his or her own world of experience. But think also of other worlds to be explored: the surreal worlds of Ernst, Dali, and Miro; the emotional worlds of Munch and Kollwitz; the political worlds of David and Goya; the personal worlds of Rembrandt and Albright. The list seems endless.

A school drawing program should have another purpose in addition to teaching young people the skills of accurate observational drawing, and the importance of creativity, expressivity and imagination. It should inspire the acquisition of world knowledge as revealed through works of artists from Leonardo to De Kooning. Students should gain graphic/aesthetic knowledge from a broad series of drawing activities in which they can form their own ideas about the world through re-creating, extending and recombining the ideas of artists. Works of art not only reveal world-views but also provide the basic content for drawing programs. *A school drawing program should be based on the essential themes, ideas, subjects, expressive qualities, styles, media, processes, techniques, problems, and solutions found in the work of artists.*

Drawing is, of course, only one of the ways to study and learn through works of art. Other important ways for students to learn about art are to re-create art as the painter, the sculptor, or printmaker might; to study art as the art historian does; and to interpret and write about

the meanings of art as the art critic does. These activities should be conducted at the same time as drawing activities. Works of art will provide the basic content for each of these other art activities.

Unique Contributions of Drawing to Knowing

What are some of the unique ways in which drawing expands our knowledge of the world?

As surprising as it may seem, much of our knowledge of the world is actually derived from symbolic sources as opposed to direct perceptions of things and events. Sounds, gestures and configurations combined within symbol systems present ideas about the world. These world models take the form of words, numbers, diagrams, plans, formulae, gestures and certainly pictures of all kinds. Through these symbolic formulations, we develop much of our knowledge of the past, other peoples, other places and even the future.

In his book *Ways of Worldmaking,* Nelson Goodman says that there are nearly as many worlds as there are ideas about worlds. And, Goodman says, of the different symbolic ways that we go about creating our worlds, no one way is necessarily better than another. Physics does not provide a better way of building ideas of the world than poetry—just a different way.

Pictures provide us with a unique way of worldmaking. Compare pictures to words, for example. Words generally have no necessary structural similarity to the objects or ideas of our everyday experience. To make sense, words must be strung together in a syntactical order. Moreover, our spoken words disappear almost as quickly as they are uttered. If we wish to refer back to words, we must record them or write them down.

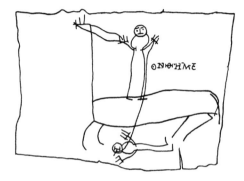

Onfim striking his enemy. The inscription in the top right corner reads, "Onfim." (APN reproduction of archaeological copy of birch bark drawing, 1984)

Onfim's drawing of a father and son on horseback. (APN reproduction of archaeological copy of birch bark drawing, 1984)

Pictures on the other hand are less abstract; they often have a somewhat isomorphic similarity to the everyday objects of experience. A drawing of a tree generally has some structural similarities to the tree we perceive in the woods. Moreover, these concrete presentations are filled with information. The word "woman" is only a reference to an individual of the female gender. A drawing of a woman may contain information about her physical appearance, how she is dressed, her age, her actions and perhaps even her emotional state. Although pictures, too, have a kind of syntax (rules for relating images to one another), it is much more flexible than that of verbal language. Objects within a picture may be arranged in a variety of different ways and still convey the same idea.

Finally pictures have a tangibility and leave at least a semi-permanent recording as well. That record allows the creator and others to return to the picture time and time again. In a very real sense the picture achieves an autonomy of its own that can transcend its creator. Consider, for example, the drawings on birchbark made by little Onfim in the 13th century in what is now the Soviet Union. Excavated from the

frozen tundra, these 700-year-old artifacts provide a view of a young boy's life, fears and dreams far more telling than the school writing exercises around which the drawings were made.

Indeed drawing is the first such symbol system children acquire without informal instruction that allows for the presentation of their complex ideas about the world.

Children learn by watching others draw and make discoveries on their own as they work and play at drawing. When it comes to worldmaking, then, drawings provide a superb way to create a tangible, concrete, possibly permanent, flexible vision of the realities. And even when young people learn to make worlds through their writing, numbers and other formulae, pictures remain the symbol system that best describes the world.

All teachers should understand the factors that determine how their students learn to use effectively the graphic-aesthetic symbol system of drawing; and school drawing programs should engage students directly in the process of worldmaking through graphic-aesthetic means.

Two Kinds of Art: The Encouragement of Spontaneous and Out-of-School Drawing

The drawings made in school, even those based on ideas and qualities found in the work of artists are not the only worthwhile drawings of young people. Art teachers need to pay special attention to the spontaneous drawings that children make outside of art class. These drawings, frequently based upon imagery of the popular media (and seldom upon the art that one might see in art museums and galleries), are often seen by students to be more important than all of the magnificent art-like drawings we might have them do in school. For it is in their spontaneous drawings that it is likely that young people *act* most like artists, creating meaningful views of their worlds. As they create their sometimes amazingly coherent "portfolios" of spontaneous drawings, they pursue the subjects, tasks and problems that are of utmost importance to them.

Each teacher should look for students who produce spontaneous drawings and encourage them through private talks and through the display of the drawings in school (with the students' permission, of course).

When school drawing explores and recreates the collective worlds revealed through art, and when art teachers encourage spontaneous drawing in which students explore whatever they think important, students and teachers shall have the best of both worlds. We shall have both the spontaneous, child-like and expressive art important to young people and school art that opens for them the more complex worlds revealed through the work of our finest artists.

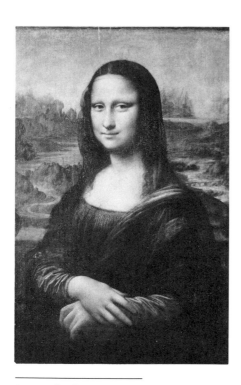

Leonardo da Vinci. *Mona Lisa*, 1503–
1506. Oil on panel, 30″ X 21″. The
Louvre, Paris.

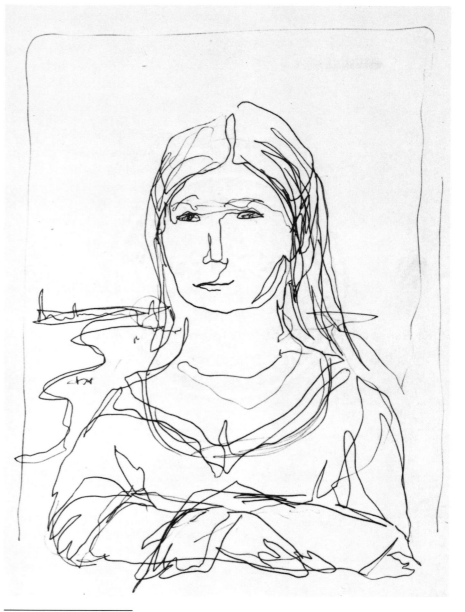

There are many drawing techniques to
be learned, and this "Mona" by a uni-
versity art student presents a fluid con-
tour-like line quality. In an ideal art
program students might be encouraged
to develop a large repertoire of different
techniques, processes and graphic pro-
grams.

How We Learn to Draw

To build an image you have to start somewhere and the easiest starting point is a kind of minimal model of what you want to represent, be it a manikin or a house or a tree, which has to incorporate some of those distinctive features of which we have been talking. You can then go and correct or modify this minimal model—which I call a schema—till you approximate what you want to represent or what you see in front of you and this approximation I call matching. In this way making the model comes before matching it to reality. So you have these two formulas, 'schema and correction' and 'making comes before matching.'—Ernst Gombrich in dialogue with Jonathan Miller

Why Does Your "Mona" Look That Way?

In the entire history of painting, probably no one work has continued to be so pervasive and notorious as Leonardo's *Mona Lisa*. This painting has been revered and maligned—reproduced from generation to generation in forms as diverse as Marcel Duchamp's 1919 "alteration" of Mona, complete with moustache and beard, to commercial advertisements. Hardly a child or adult is not familiar with her enigmatic smile.

When requested to draw Mona's likeness from memory, students, teachers, and young adults display a number of similar and strangely inaccurate features in their drawings. The eyes, for example, are almost consistently drawn high on the forehead; the foreshortened arms, which in Leonardo's painting rest on the arm of a chair, are usually drawn frontally in her lap; and her nearly three-quarter view head is typically turned to face full front. How might we account for this consistency among drawings across cultures and among people of various ages? And why do these particular features seem to be emphasized? Why also do most drawings appear to have a distinct style, showing traces of the culture and even the physical features of the artist? Answering these questions will also shed some light on the process by which we all learn to draw.

Five Major Factors that Determine Drawing Development

The six-year-old child's static geometric drawing of a man, the young adults' drawings of the *Mona Lisa* and Michelangelo's anatomically explicit drawings all are affected by five factors. The character and quality of every drawing is determined by the relative intensity of each factor and by the ways in which the factors interact. These factors range from characteristics possessed by all humans to unique expressions of individual genetic inheritance and specific cultural determinants:

1. All humans are born with a tendency to draw objects as simply as possible, to avoid overlapping, to depict things from characteristic views and to arrange lines and shapes at right angles.
2. Drawing development may be likened to a process of organic growth where at times a new image emerges slowly from a previous one, and where at other times images change abruptly through a chance discovery in the accidental lines and shapes one has drawn.
3. Drawing development is dependent upon borrowing and employing the images of the art of a culture.
4. Drawing achievement depends upon individual abilities and traits including the desire to draw, visual memory, observational and motor skills, imagination, inventiveness and aesthetic preferences.
5. Finally, how one draws is affected by the opportunity to learn and apply drawing skills, the amount of encouragement to draw and the type of drawing instruction one receives.

Intrinsic Graphic Biases

Presenting ideas through drawing is a part of the human cultural heritage. By watching others draw or write, or by experimentation with a finger or a tool, young children learn that they can make marks on surfaces. Initially, their biological heritage influences the sorts of marks they make. These inherited tendencies are the intrinsic graphic biases.

Young children—and even older students and adults—draw things in particular ways because, at least at the outset, they simply have no choice in the matter. Unless experience and education lead students to transcend some of these biases, they will continue to use the same graphic solutions that young children do and may thus limit themselves to a lifetime of involuntary child-like graphic behavior.

Simplicity and Non-differentiation

We all tend to draw things as simply as possible, as long as our depiction achieves a satisfactory likeness to the object. This bias toward simplicity takes many forms. It accounts for such drawing characteristics as:

Avoidance of overlap. Each object occupies its own territory, not to be infringed upon by another.

Presentation of objects from the most characteristic point of view. People are seen from the front; horses and cars from the side. This aspect of the simplicity bias, then, accounts for the tendency to

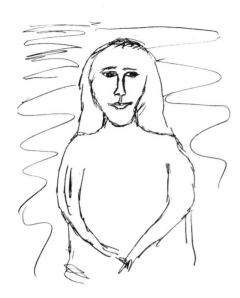

This "Mona," drawn from memory by a sculptor with a fair amount of art training, shows a frontal view, eyes high in the forehead, short sausage-bent unforeshortened arms, and an absence of detail. These graphic biases persist for a lifetime, although with practice we can overcome and mask the effects of some of them.

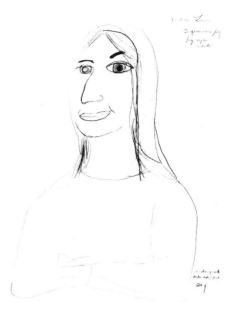

Although the undergraduate who drew this "Mona" managed to show the three-quarter view of the head, she still presented the arms from a characteristic unforeshortened view. The shortened arms may have been "adjusted" to fit within the format, and the schematic eyes, nose and lips are affected by the bias toward simplicity.

change *Mona Lisa*'s three-quarter view, rearranging the position of both hands and face to assume a characteristic front view, and to show the arms in a more simplified and unforeshortened manner.

Placement of objects at right angles to one another. Arms emerge perpendicularly to the line of the body; chimneys appear at right angles to roofs, and people walk up hills at a 90 degree angle to the line of the slope.

Non-differentiation of parts. Straight arms and legs are drawn without angles or bends at the joint. Another aspect of non-differentiation involves depicting, as the same size, objects that are both large and small as well as those that are near and far.

Conservation. A tendency to use a single graphic configuration in as many ways as possible. Drawings of cows with human heads and horses with human legs are a typical example.

Format conformation. A tendency to arrange objects to conform to the shape of a format. Children arrange the lines and forms in their drawings to fulfill the implicit demands of the shape of the paper, whether circular, oval, or rectangular. This principle is also seen to work in another way, so that a long human body may be given several sets of arms; a long horse body may require six saddles or ten legs (even though the child knows that horses have only four legs). Here we see the dual consequences of a single intrinsic bias. On the one hand, it sometimes produces drawings in which there is a pleasing correlation between the shape of the format and the placement of objects; and on the other hand, the results are sometimes humorous.

Intuitive balance. With absolutely no instruction in composition or design, humans have a tendency to produce drawings in which one shape or group of shapes balances another or others.

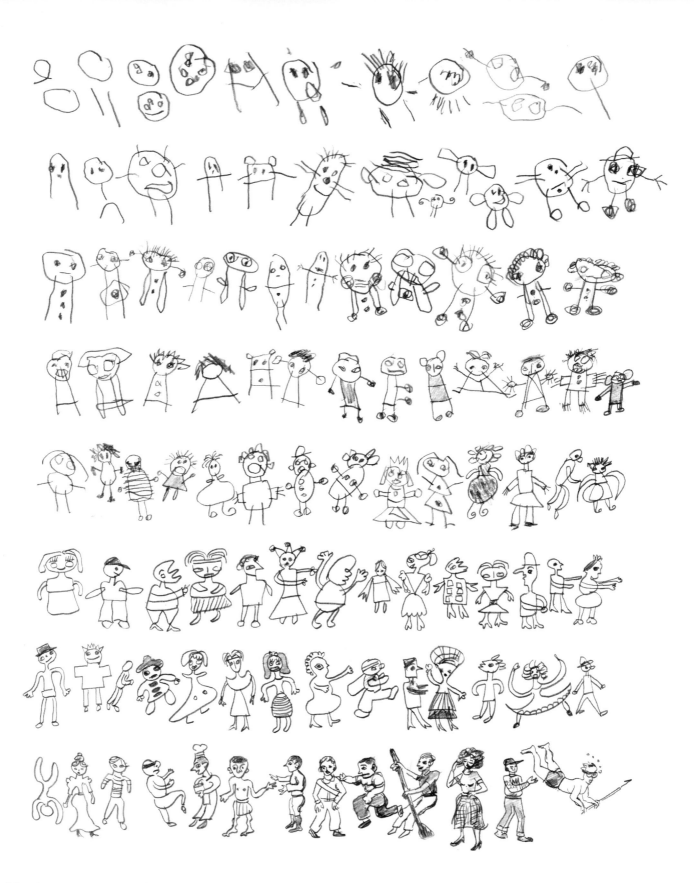

Although art educators have been taught to see drawing development as advancing from one general stage to another, it is more useful to characterize it as a series of hundreds of gradual steps. In this illustration the figure drawings of many children from several different countries have been re-drawn and arranged in a developmental sequence showing the gradual unfolding of graphic growth. The features of higher level figures are elaborations of lower level figures. These elaborations could also be seen as the overcoming of intrinsic biases toward non-differentiation, symmetrical balance and non-overlap.

Few individual children follow such a step-by-step gradual pattern. When young children see the drawings of older children they will frequently jump several steps. Because of the intrinsic biases, the drawings by children from different countries are alike in some respects. They also exhibit cultural features. Children's drawings from Egypt, Japan, America, and New Guinea each have unique stylistic characteristics.

Organic Growth and Fortuitous Discovery

Embellishment. At least some individuals have an intrinsic propensity to embellish and to fill space in a decorative manner. Decorations may be responses to the desire to fulfill the implicit demands of a format, to achieve a balance between forms, or, as in pattern-making, the desire for decoration may stand on its own.

Intellectual realism. Although individuals strive to achieve correspondence between the object perceived and the object drawn, they are sometimes willing to forego a perceptual realism for what has been called intellectual realism—"drawing what one knows rather than what one sees." A baby in the "tummy" of the horse or human mother-to-be, the x-ray view of an underground world, or a house, from which the facade has been stripped to reveal the interior rooms.

The inherited biases don't go away. They affect the character of drawings, and account for many of the features found in the drawings of young children. Intrinsic biases still affect adults' drawings but often in less obvious ways.

Art educators are caught in the dilemma of trying to preserve the delightful naive qualities of child art, while at the same time helping the young child to acquire drawing expertise. "Naturalness" in children's drawings should be preserved only as long as children themselves want it preserved. Teachers should help students to overcome some of their natural and, perhaps, undesired drawing tendencies by guiding them in directions they would not normally go. On the other hand, some of the natural tendencies—e.g., aesthetically valuable biases toward balance, decoration, simplicity and clarity—are better developed than subverted.

The cultural styles that most American children attempt to achieve demand that they overcome many of their intrinsic biases. In the absence of good instruction, students often become discouraged and, as a result, stop most of their drawing activity.

In addition to a predisposition to draw in a simple and undifferentiated manner, individuals also have the desire to incorporate more complexity and thus more meaning into their drawings. Adding complexity involves fortuitous discovery and serendipitous graphic invention.

The Unfolding Aspect of Drawing Development

During most of the 19th century, it was assumed that the only proper way to learn to draw was through a series of rigid exercises dictated by a teacher and usually outlined in a textbook. But at the turn of the century, a number of teachers and psychologists discovered that drawing development followed a natural process of unfolding. Children's graphic images seemed to develop in natural and orderly steps from simplicity to ever greater levels of complexity, the result of which was often visual realism.

Simplicity in drawings results, at least partially, from the intrinsic biases outlined earlier. But another competing factor is the desire for

greater complexity. Drawing is thus conducted within a state of tension between these two tendencies.

The move towards complexity frequently takes the form of small changes (rather than giant steps) made in the way the child typically draws figures and objects. For example, the tadpole figure, which consists of a large head with two legs attached, often undergoes a metamorphosis where the space between the legs sprouts a navel or a long row of buttons, giving it a more body-like appearance; then a horizontal line connecting the two leg-lines is drawn, and a definite body has been achieved; and now the arms that were once attached to the head are moved to the newly created body. This process of unfolding continues over years until once straight stick-like arms and legs are thickened, gradually bent and finally given sharp angles at knee and elbow joints.

To think of this movement toward complexity, however, as a few simple stages is misleading—it actually occurs in literally thousands of tiny steps and some occasional leaps (discussed later). And although most developmental accounts end with the ability to draw realistically, visual realism is not the only possible end for drawing development. There are many different cultural, stylistic termination points, of which this is only one.

But why do drawings become more differentiated as students get older? First, students' ability to cognitively process information increases, and they gain more experience—both with objects in the perceptual world and with the drawings of others (of older students, adults, artists). As they practice drawing and gain graphic skills, their perceptions of objects in their drawings fail to conform in complexity to their perceptions of objects in the world and in the drawings of others. They then become dissatisfied with their simple drawings, and wish to incorporate more information, more detail or more complexity into the drawings. Drawings are then altered so that they might resemble more closely the objects in the external world or, more often, the drawings of others. Borrowing from the images of others often inspires leaps in the developmental process.

Fortuitous Discovery

Most accounts of children's drawing development describe a gradual and almost predictable increase in complexity. However, many children take enormous leaps forward in their drawing development as a result of chance occurrences or outside influences. The French psychologist Luquet, who studied children's drawings early in this century, first described a stage of drawing development that he called "fortuitous realism." Through spontaneously scribbled contour, line or shape, a child can create a chance resemblance to some object or figure. The child will then immediately "name" the scribble as that object or figure. And subsequently it is possible for the child to attempt to draw deliberately what was first drawn "fortuitously," thereby consciously using the results of such discoveries. In this manner new configurations are

incorporated into the young artist's repertoire. These chance images grow from the drawing process itself and sometimes have little connection to objects from the external world. In the drawings of older individuals—adult artists as well—chance images may appear when a line goes awry and the unintentional becomes the intentional. These discovered images follow their own rules, which may in no way conform to the "rules" of the perceptual world, and may often display a complexity and a degree of invention that earlier "intentional" drawings did not.

But metamorphosis in drawing needn't wait for a graphic accident. We have observed four-year-old children who systematically begin drawing with a deliberately meandering line, watching to see what form the line suggests; and as soon as an intriguing configuration emerges, it is elaborated upon.

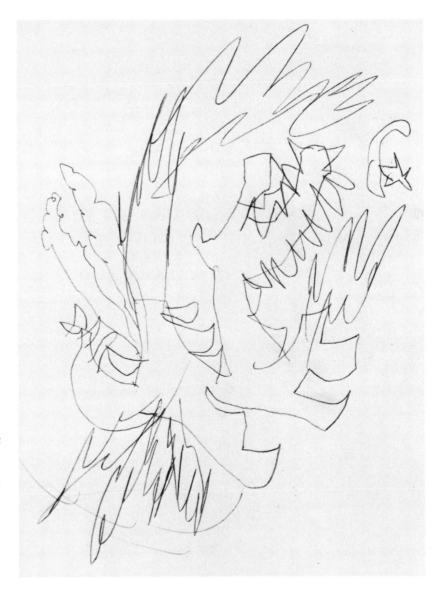

Drawing development sometimes takes a giant step forward because of a chance occurrence during the act of drawing. In fact, some artists and even young children try to make accidents happen. Five-year-old Dane made it a practice to discover new things in his scribbles. In this drawing he first made some lines that reminded him of a horse (the head with its open mouth is in the upper-right quarter of the drawing). But since his lines had taken some very unhorselike turns (there is an erupting volcano on its back) Dane called it "a space-horse that is a robot. He shoots fire." Once the space theme had been established, a star and a quarter-moon were added. The horse was also embellished with sharp teeth and surrounded with fire and smoke.

The two organic processes we have just described—the former, the desire for more differentiation in drawings, and the latter, the desire merely to discover the different—are tremendously important to drawing development, but only if they are considered in light of cultural influences.

Borrowing Images From Others

Much of the traditional art instruction in the United States, especially for young children, has been based on the assumption that the naturally unfolding process of acquiring higher degrees of realism was the complete explanation of drawing development. Since each child was seen to develop his or her own graphic equivalents for the objects of experience, many art educators thought it wrong to interfere. The teacher could nurture and encourage, but not actually instruct in "how to draw." Evidence suggests, however, that almost every image we draw owes something to the graphic images of others.

Our graphic "language" has at least some of the same predictable regularities as verbal language, and relies on a culturally specific "vocabulary" and style.

The Necessity of Cultural Images

There is a longstanding and still widespread belief that artistic influences are neither necessary nor desirable. Lowenfeld, for example, thought that the "most beautiful, natural, and clearest examples of child art" were to be found in those remote areas of the country where there was little influence from the popular media or from "education." Lowenfeld's strong belief notwithstanding, there is ample evidence which contradicts both the idea that influence-free art is even possible and that any influence must necessarily be detrimental.

Nahia, an Egyptian village in Giza, would appear to be an ideal place for the natural art of childhood to unfold. There are few if any comic books, magazines, advertisements, book illustrations or even illustrations in school readers. About the only adult art that children see are a few wall paintings commemorating pilgrimages to Mecca. (Since these paintings are made by adults with no special art training, they are not very different from the paintings made by the older children of the village.) There is a school art program in which children are encouraged to draw their experiences, but the teachers seem to make no attempt to influence the drawings of the children. In short, the children are free to practice their art under conditions that are almost totally free of adult imposition of images.

What kinds of drawings do the children produce? In the absence of adult graphic influences, the children influenced one another. Even the older children of the village, who must have influenced the younger ones, were able to bequeath only a very narrow range of graphic images. The children of the village drew only three main types of heads. One of the most frequently drawn versions was a profile formed by the Arabic numeral 4 (resembling our 3 drawn backwards). They also drew only three types of bodies, each highly geometric. The most prevalent

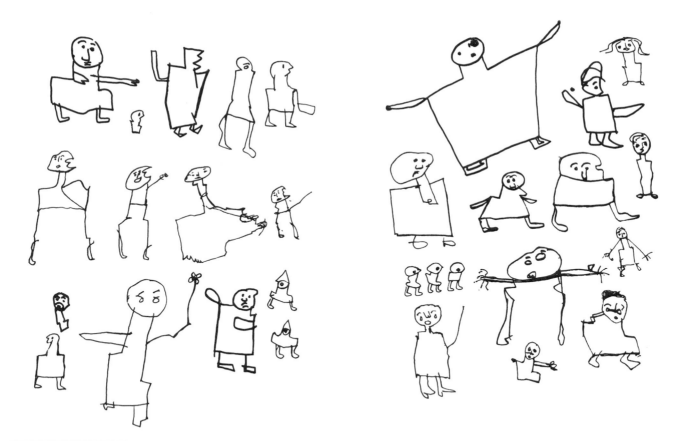

These drawings of humans are unmistakably by children. And yet anyone familiar with the art of young people will see how very different these Egyptian drawings are from the drawings of American children. These drawings by nine-year-olds show their struggle to achieve the standard body-form employed by most older Egyptian children.

form was a rectangular torso with a fused neck, drawn by approximately 70% of the village children. This type of body appears in fewer than 4% of American children's figure drawings. The arms and legs of the Egyptian figure drawings were also regular and predictable.

These findings can provide some important insights regarding the essentials of learning to draw:

> A culturally specific standard "vocabulary" of shapes and configurations largely composes a given "graphic language." (We find very different sets of configurations in the drawings of children from different cultures.)

> Personal perceptions of objects frequently have less effect on how objects are drawn than the standard cultural symbols.

> If young people have few graphic configurations to borrow from adults, then they borrow them from other children. (Children's drawings often provide the strongest influence on the drawings of other children).

> The fewer the graphic influences, the more graphically impoverished and predictable a style will be.

Cultural Borrowing And Creativity

We have little choice, at least initially, regarding whether or not we will borrow graphic images from others. The same applies to the native language that we will speak. Some may claim that such borrowing diminishes creativity. But is this so? Consider creativity in poetry. Poetry is mainly composed with conventional words but combines those words into unique metaphorical images. Conventional graphic images, too, can be combined in infinite ways. And far more than words, graphic images can undergo endless fortuitous changes.

Without borrowed images—culturally-based graphic forms that enrich drawing—the language of drawing would be much poorer. The tired old issue "Should children be allowed to copy?", then, is not so much an issue at all. Drawing "in the style of," or doing things in another artist's way is a vital part of learning to draw. And although borrowing is necessary, the slavish copying of the work of another has, perhaps, only limited usefulness in some aspects of drawing skill development. The questions that should concern us are: what form does our borrowing take?, for what purposes?, and does it expand or restrict our creative potentials?

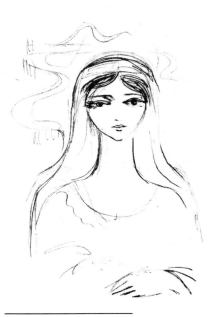

This "Mona" is drawn from memory by a well-known Egyptian artist. Despite the artist's art education and professional experience, the drawing appears still to possess some of the cultural features he may have learned as a child. The head and the eyes are reminiscent of candy dolls eaten at feast time that have a powerful influence on the drawings of Egyptian children. Other influences, however, are probably from the world of art. The elongated neck is Queen Nefertiti-like, and the foreshortened arms can probably be attributed to art training. The frontal-view of the head might be the result of the intrinsic bias, draw-the-most-characteristic-view.

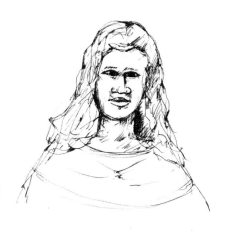

This "Mona" by a Nigerian artist not only shows evidence of art training in such things as the anatomy of the head and the cross-hatching technique, but it also contains strong traces of the physical features of the artist himself and of the models that he drew as an art student. Once graphic habits are developed, they exert a conservative force hindering change and development.

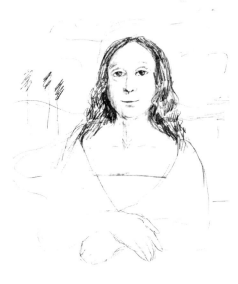

The discipline of drawing involves, among other things, acquiring a variety of graphic programs and expressive techniques. This "Mona" was drawn from memory by an artist who years ago learned a standard way of drawing heads, eyes, noses, and lips. She modified these in light of her memories of the features of "Mona." The artist has also developed facile techniques for shading and indicating trees.

The Role of Individual Characteristics and Abilities

How well one learns to draw depends in part upon individual traits—the extent to which one possesses the desire to draw, a visual memory, observational and motor skills, imagination and inventiveness, as well as graphic and aesthetic preferences. But of all the individual characteristics, desire is paramount. Without it, students are unlikely to achieve more than ordinary development. Even students with only modest natural abilities can still learn to draw well if they have a strong desire to do so.

These personal traits are, of course, beyond the control of any art teacher. The teacher can, however, encourage students to use to good advantage the imagination, graphic motor facility, visual memory and other endowments they possess. And sometimes a student's modest desire to draw well can be nurtured until it becomes enormous.

The Discipline of Drawing

Finally we come to the area of drawing development that should be of the greatest concern to teachers—the role of the teacher in providing opportunity, encouragement, practice, skill development and instruction in learning to draw.

Even the youngest students, if effectively taught, can produce imaginative and inventive drawings; they can start to depict spatial relationships through the overlapping of objects, show action in figures through the placement and bending of limbs and consciously produce lines and shapes that complement one another. They can begin to develop a style and to infuse their drawings with mood and feeling—things that, left to their own devices, most students do not learn to do very well.

Essentially, disciplined drawing instruction in the public school would involve, (1) assisting students to move beyond those intrinsic biases that impede drawing development; (2) setting the conditions that facilitate a rapid organic-like unfolding, as well as encouragement in the process of imaginative discovery; and (3) turning to the world of art in order to provide students with information about the ideas, styles, expressive qualities, problems, techniques, skills and processes employed by professional artists. One basic task in teaching the discipline of drawing is to find ways to teach drawing through drawings.

Conclusion

As a symbol system for building ideas about the world, the ability to draw is far too important to remain undeveloped. But, without an art teacher to provide instruction in the discipline of drawing, most students will remain inhibited by intrinsic biases, reaching only the regrettably low level of drawing commonly achieved by young people in our culture. The exceptions, of course, are the few individuals who develop the ability to draw through self-instruction based on culturally accessible models.

Ten different sections from ten different
works of art from the Abstract Expres-
sionism Gallery of the Albright-Knox
Art Gallery or sections from Judy Pfaff's
installation of *Rock/Paper/Scissors* were
incorporated into a single composition
by a 14-year-old student.

Chapter Three

The Comprehensive Drawing Program: Principles and Practices

We have said that the primary objective of the school drawing program is to expand conceptions of the world through the creation and re-creation of artistic knowledge; and we have also said that drawing development involves an interaction of universal inborn propensities, cultural graphic borrowing, individual innate skill, passion, practice and opportunity. Now, we will present an overview of a comprehensive school drawing program based on these ideas. Our plan is, of course, an ideal, but one that can be accomplished in schools.

Components of the Drawing Program

Some teachers devote almost all the drawing program time to observational drawing. Others, especially in the elementary grades, have students draw primarily from their remembered experiences. Still other teachers include imaginary and experimental drawing, ask students to draw from "verbal motivations," or think of drawing as a way to increase students' awareness of the elements and principles of design. In our experience very few teachers work systematically to increase students' skills in drawing from memory. Just what should be included in the school drawing program? Our answer is that the drawing program should be based on a careful balance between five major types of drawing activities and five groups of factors that need to be taught continually, regardless of the type of drawing activity.

Five Types of Drawing Activities

Table 1 presents the five major types of drawing activities and, depending on the grade level, a suggested amount of time to be devoted to each. It is most important to include *each* of these five types of activities in the school drawing program. The chart shows not only that a significant amount of time and emphasis should be allotted to each and where that emphasis might be placed, but also that the emphasis and amount of time devoted to each type of drawing might change as students develop drawing skills. Naturally, each teacher will establish his or her own drawing activity priorities.

Five Groups of Factors

The five groups of factors influence, at least subconsciously, everyone who draws. A school drawing program should help students employ on a conscious level at least some of these factors in each drawing that they produce. As students create and re-create the meanings of works of art, they continually need to consider the consequences of using each group of factors. At the same time we should be aware that an artist can never consciously control all the aesthetic and visual elements of a drawing. Once established, the media, sensory, formal, expressive and ideational elements of a drawing frequently go well beyond the intentions of their creator. These aesthetic and subject matter elements frequently enrich, complicate, extend and mystify the meaning of works of art. Teachers of young children should not be overly concerned with teaching design and composition (although their drawings will always have a composition). Students of all ages should be encouraged to continually attend to the thematic, subject matter and symbolic aspects of drawings.

How Much Time Should be Devoted to Drawing? And Who Should Teach It?

Any good school art program should consist of a healthy mixture of art historical, art critical, and art studio activities. The studio program ought to include painting, printmaking, sculpture, assemblage, collage and the crafts. However, if art in schools purports to create and re-create artistic/aesthetic knowledge, and since drawing provides the means to explore more ideas more quickly and with more benefit than in any other studio activity, then *drawing should be the principal studio activity*. And, if it is taught as this book suggests, then most of these drawing activities will incorporate art history and art criticism as major ingredients.

Children in the elementary grades should be drawing nearly every day. Thirty-six periods a year with the art specialist hardly provides adequate time for even the drawing program envisioned here—let alone all the other elements of an art program. Therefore, the elementary drawing program should be the joint responsibility of the art specialist (when there is one) and the classroom teacher. The classroom teacher

Table 1 Suggested Amounts of Time To Be Devoted to Five Major Types of School Drawing Activities (in percent of total drawing time)

Drawing Type	Grade Level			
	K–3	4–6	7–9	10–12
Observational	15	20	25	25
Memory	25	20	20	20
Imagination/Fantasy	25	20	20	20
Verbal to Visual	25	25	20	20
Experimental	10	15	15	15

Table 2 Suggested Emphasis To Be Placed Upon the Five Factors That Influence Drawing Development

	K–3	4–6	7–9	10–12
Factor I Theme, subject, symbol	Almost always	Almost always	Almost always	Almost always
Factor II Form, composition, design	Sometimes	Sometimes	Often	Almost always
Factor III Style and expressive quality	Almost always	Almost always	Almost always	Almost always
Factor IV Media and technique	Sometimes	Sometimes	Often	Almost always
Factor V Motion, emotion and duration	Sometimes	Sometimes	Sometimes	Sometimes

has the time and the flexibility to incorporate a variety of drawing activities into the weekly program, as well as other studio, historical and critical activities, some of which may take only a few minutes of each day. The art specialist should take the lead in helping classroom teachers to plan their art programs. This book, then, can be of equal benefit to both the art specialist and the classroom teacher.

In the secondary grades the art teacher should aim for a satisfactory balance among the various components of the art program. Again, the greatest benefit from an art program can be achieved through attention to art historical and art critical aspects in relation to drawing activities.

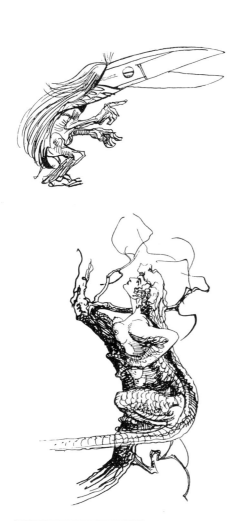

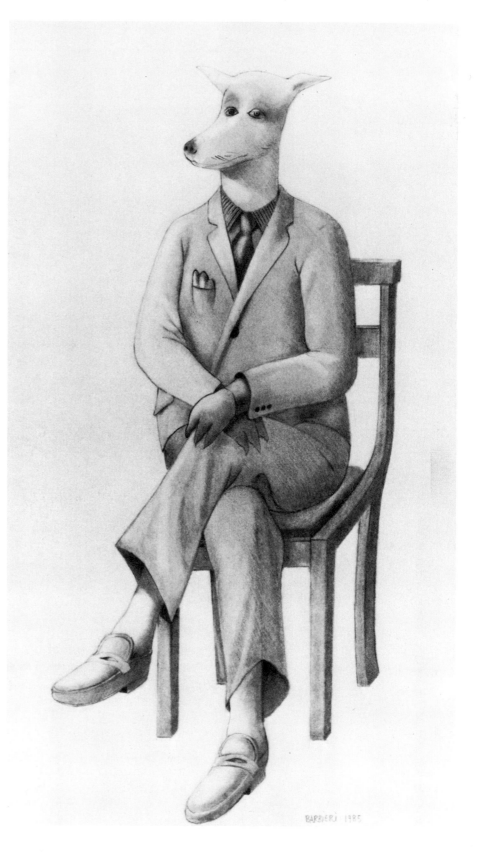

The drawings of Joseph Barbieri and Heinrich Kley can motivate children to use both imagination and skill in drawing. Kley worked in combinations of unlikely subjects. Here, he unites a pair of scissors with a creature that is part animal, part human. He creates another being that is both womanly and reptilian. Barbieri's sense of calm and detachment makes his subject, the man-dog, both humorous and frightening.

Drawing Definitions and Extensions: Approaches to Experimental Planning and Teaching

The variety of work going under the name of "drawing" makes it increasingly more difficult to define the term.—Robert Kaupelis

Definitions and More Definitions

What *is* drawing? Through their drawings, artists not only show us ways of perceiving the world, but they may actually create new conceptions of the world or, as some would say, whole new worlds. In any case, artists generally care little for definitions. It is left to those of us who teach or write about drawing to grapple with the question of where the boundaries of drawing lie and how those boundaries might affect the teaching of drawing.

If drawing is, as Paul Klee once said, "taking a walk with a line," how then would Klee account for the tradition of shading which has so fascinated some artists since the Renaissance? How do we classify enormous calligraphic-like linear work in black and white? If it is done on canvas, is it a painting and on paper, a drawing? And if we exclude color as a major factor in drawing, then how do we categorize the drawings of David Hockney, who gave colored pencils new respectability, or drawings of interior designers and architectural illustrators who rely heavily on color. And what of drawings that aren't even drawn but sprayed from the nozzles of air brushes?

A recent drawing exhibition at a major art school included a wall of neon strips and a room piled high with welded metal rods. Were they

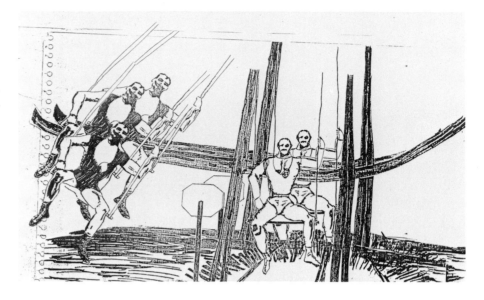

Is this a drawing? Have students make drawings from paintings; reproduce several images on the copy machine; cut-up and recombine the multiple images, make more copies, more recombinations, etc. etc. Well, if it isn't a drawing, still it was made in a drawing class.

classified in this way because these forms share a linear structure with traditional forms of drawing? Even certain earthworks, when viewed from great distances, register as drawings because of their linear character. And when seen from an airplane or from an aerial photograph, Michael Heiser's linear trenches carved across Nevada deserts or built into reclaimed Illinois strip mines seem as much earth-drawings as earth-sculptures. When an artist draws on a photograph, is it then a drawing or still a photograph? Most might agree that Michelangelo's preliminary sketches for the Sistine ceiling are drawings, but few might be willing to concede that the result of Calder's twisting and curving wires to resemble acrobats was a drawing. Yet they look like drawings—wire drawings. Does our quibbling about the difficult cases even matter?

And as if there were not enough disagreement about the visual and formal characteristics of drawings, what of some of drawing's functional attributes? Is drawing, as Daniel Mendelowitz claims, most notable for its informal and subjective nature, and for its immediacy and "intimate contact with the act of creation"? Mendelowitz is correct about some drawings—the sketches and the fragmentary notations that allow us to "peer" over the shoulder of the artist, to study the visual thought processes of the artist, to gain insights into the process of observation. These working drawings seem almost to transcend time. For example, the action sketches of Rembrandt or Delacroix seem more of our own time than their paintings. There is something almost universal about an artist's working drawings.

But on the other hand, Mendelowitz is wrong. The fact that the drawings of so many contemporary artists are created, sold and collected as art works in themselves shows that his claim that drawings are made simply for the artist's own use, rather than for the client may not be altogether accurate. The existence of galleries that specialize in

If Lichtenstein can derive his images from the comic strips, then why not our students too? Have students work from the Sunday comics. Assign them to do drawings in which the compositions are left essentially unaltered, but abstract the images until it is virtually impossible to determine the original subject matter, and simplify the patterns of light and dark. These drawings by university students were done with brush and ink.

The French artist Jean Dubuffet some-
times filled his drawings with thousands
of dots, marks, and lines. His technique
is a starting point for this seven-year-old
student.

drawings, a journal devoted to drawing, a society of drawing and art-
ists whose sole production is drawing suggests that drawing is not just
informal and subjective, nor merely a means to some other artistic end.
Drawing is frequently an artistic end in itself.

So what does make a drawing a drawing? Is it the medium, the
process, the intent, the outcome? Perhaps all these things and more.
Ultimately, drawing is one of those "essentially contested concepts" so
complex, so value laden and so subject to change and redefinition that
there will never be an entirely satisfactory once-and-for-all definition.

Does it matter whether a teacher can define drawing before begin-
ning to teach it? Probably not. Perhaps what is important is that draw-
ing not be defined too narrowly—that drawing be seen as a means to
explore ideas. The more open the teacher's attitude toward the possibil-
ities for extending and perhaps even breaking through the boundaries
of our present conceptions of drawing, the better the teacher will be
able to guide students to new insights through drawing. And how might
a teacher stretch the boundaries of drawing? Perhaps he or she might
begin by experimenting with the following approach to devising draw-
ing activities.

Creating Experimental Drawing Projects

Although the re-creation of the images and ideas of art is perhaps the best source for the content of a drawing program, the program should by no means be limited to what artists have already done. On the contrary, teachers should base their teaching on the content, ideas, images, processes and techniques found in works of art, as well as on what is *suggested* by works of art.

Drawing is a symbol system that carries its traditions, but it also carries with it the seeds of its future. The new images and processes of future drawing will evolve from what drawing is now. A creative idea

In this drawing an old theme has been integrated with the refuse of the modern age. An evil satyr drags a burning cloud of popular imagery in an eleventh-grade student's witty version of Schongauer's *Temptation of St. Anthony.*

seldom arises "out of the blue." Indeed most creative ideas expand existing ideas. Art teachers can participate in the evolution of drawing by playing with and extending its images and processes. The act of extension is not necessarily easy, but it can result in exciting classroom drawing projects and expand the ways we teach drawing.

This is how it can be done. We look at many different drawings and other works of art. In addition to experiencing art for all the usual and enjoyable reasons, we also wait for the works to "suggest" drawing projects. We then draw and write these suggestions on index cards and place them in a file. The plans might be cryptic or quite fully developed. In either case an embryonic plan for a drawing lesson is recorded. On a rare occasion the plan might nudge gently at the boundaries of drawing and thus participate in the process of redefining drawing, but it can always provide the ingredients for an exciting drawing lesson.

Battleship Potemkin

Any image can suggest a drawing lesson—or a dozen lessons. For example, the horror-stricken face of the nurse from Eisenstein's movie *Battleship Potemkin* (1925) is one of the most vivid and unforgettable images in cinema. Among other things, the image has inspired some of the distorted portraits by the British painter, Francis Bacon. The image seemed like a good jumping-off place for a drawing lesson, but why work only from the cinematic image as Bacon has done? As individual students walked through the door of the art room they were stopped, asked to "pull a face"—a "Potemkin-like" face; they were then photographed with instantly developing film, and in a minute or so they had an image of their own distorted face from which to draw.

By Alyssa, age 8.

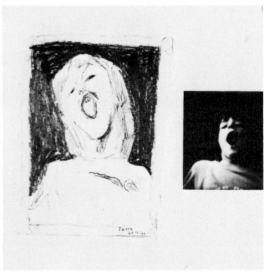

By Jesse, age 8.

Every work of art—every drawing, painting, sculpture, photograph—is potentially the source for dozens of drawing projects.

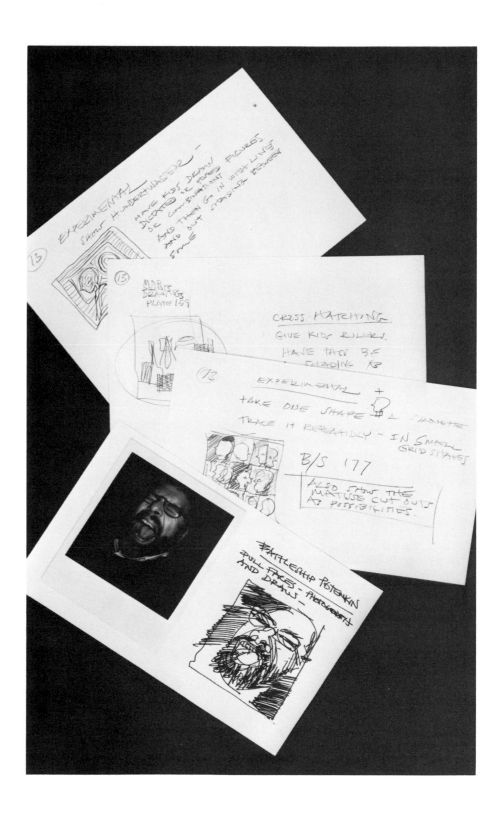

If Wood's *Daughters of the American Revolution* only knew what was behind them! (Apparently derived from Picasso.) And to make matters "worse" (but perhaps more meaningful), they have been attacked by "Jack the Dripper." The drawing was made in a university introductory drawing course for non-art majors.

It is extremely difficult to break away from the usual in drawing. Tastes and training push us toward the production of harmonious and homogeneous drawings. But drawings need not always be harmonious. Have students combine images from drawings which contain contrary characteristics.

Slides of drawings by de Kooning and Tiepolo were flashed on a screen while a university student worked quickly with a stick dipped in ink and ink washes.

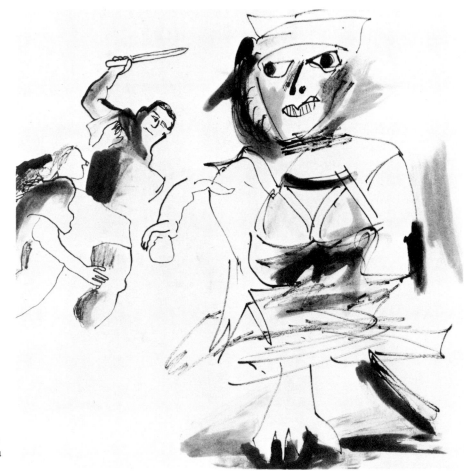

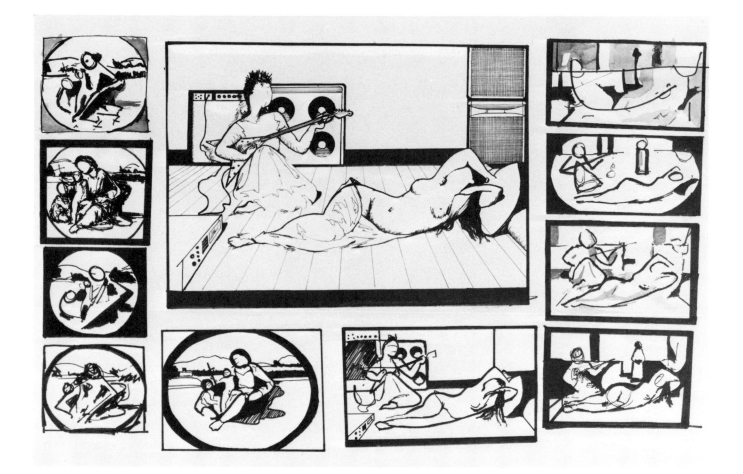

The style is consistent and the subject matter incongruous in this series of brush and ink sketches that push a Renaissance Madonna and child through stages of abstraction, and places the figures from an Ingres painting in a contemporary setting.

This drawing, again by a university student, has a series of Dubuffet drawings swarming around an academic portrait.

Drawing from paintings in the Albright-
Knox Art Gallery. Morgan Russell's
Synchronomy in Orange: To Form,
1913–1914, is in the background.

Teaching Drawing Through Works of Art: Lessons From Perugino and David

It rarely happens, if it happens at all, that a writer can achieve effects much larger than the effects achieved in books he has read and admired. Human beings, like chimpanzees, can do very little without models.—John Gardner

The ability to draw well, as to write well, depends not only upon developing skills and increasing awareness of the world, but also upon knowledge of the problems of art and artists.

Students develop their drawing skills both by studying how other artists work and from their own experimentation. In the beginning, the images of others—primarily those of other students and from the popular media—are important models. Though important, these early models provide only a common picture language. If the students are to achieve "effects . . . larger than the effects" achieved in drawings seen and admired, then they must go beyond these first models. Surely, if these were adequate models, then we would have little need for art classrooms and art teachers. It is here that we can provide students with the very best sources for learning to make art. One role of the art teacher is to introduce students to the panorama of the fine arts from which they might learn the discipline of art, whether the drawings, paintings and sculpture of such twentieth century artists as Picasso, Oldenberg and Hockney, or such old masters as Rembrandt, Rubens and Raphael.

In Chapter 4 we suggested ways for developing experimental drawing projects from works of art. Here we illustrate the variety of lessons that may be developed from a single work of art and suggest approaches to teaching drawing from works of art.

Students aged 15 and 16 made these 15-second gesture drawings at the Albright-Knox Art Gallery while looking at Picasso's *Glass, Vase and Fruits*, 1937. Almost any work of art can be the subject of quick studies such as these. Quick gesture drawings develop fluency as well as skill in perceiving and delineating the compositions of works of art. The richer the subject matter from which students draw, the richer their drawings will be.

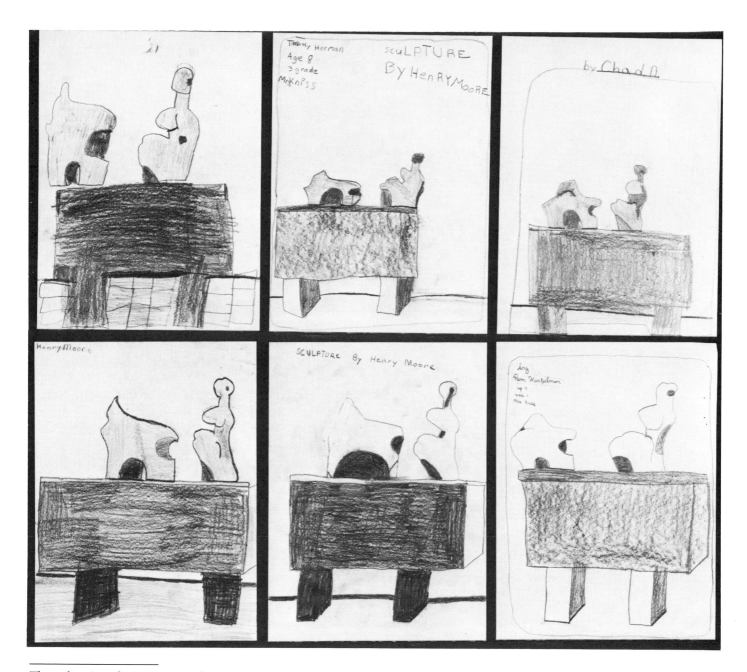

These drawings from a projected transparency taken of a sculpture by Henry Moore (from the collection of the Albright-Knox Art Gallery) show the result of carefully directed observations. Third-grade students were told to use "extraordinary perception" in looking at the sculpture. For 20 minutes they discussed every aspect of the sculpture, paying special attention to the shapes of the "in between spaces," the hollowed-out places, and the lights and shadows. The "extraordinary perception" led to extraordinary drawings. Although the converging lines of the supports for the sculpture base were not discussed, quite a number of the students observed and rendered the supports accurately.

Perugino's *Delivery of the Keys*

Almost any work of art that has been drawn, painted, sculpted or constructed could be used as a model from which to develop art lessons. The following sample lessons are devised from Perugino's *The Delivery of the Keys*. Painted for the Sistine Chapel in 1482, *The Keys* may seem an odd choice since it appears far removed from the experience of most students. Yet the painting deals with many of the same graphic concerns faced by artists and art students today. Indeed, the painting is an intriguing and somewhat curious exercise in the investigation of perspective and a good deal more.

The Delivery of the Keys imparts at once a sense of open space and clustered figures, of activity and calm. The subject is Christ's delivery of the keys of the Kingdom of Heaven to Peter. This action takes place in the center foreground while the remaining apostles (and a number of Perugino's contemporaries) look on. Behind the solid line formed by the Apostles and onlookers, there stretches a vast expanse of space in which may be seen distant figures, some standing calmly, others moving dramatically. The eye of the viewer is drawn to the single vanishing point, centering directly on the doors of the church, a building flanked by two Roman triumphal arches. Above the horizon line, the hills, too, point like arrows to the central church, their regularity broken only by lacy trees.

What do children say when asked to respond to the painting? The following is part of a discussion with a class of fifth grade students. The discussion began with the teacher's description of an early visit to Italy by Peter Paul Rubens so that he could study the master art works in Rome, and fill his notebooks with valuable information about anatomy, composition and technique.

Following Rubens' example, the students were then taken on an imaginary trip to Rome. Upon their arrival in that glorious city, they were immediately transported to the Vatican. The teacher says:

> Imagine that we are now in the Vatican in Rome. Of all the things to be seen there, the most famous and the most magnificent is the Sistine Chapel. As you wait among the throngs of other visitors from all over the world who have come to see the masterpieces here, there is a sense of excitement and of anticipation. As you descend the long flight of stairs leading to the door of the chapel, a voice is heard to repeat in several languages, "You are about to enter the Sistine Chapel. We ask that you maintain silence." This request is in keeping with the air of awe and wonder felt as you prepare to confront the great works of art in this sanctuary. You enter the chapel.
>
> The high ceiling and the end wall first attract your attention with Michelangelo's marvelous and at once familiar figures, with God and Adam dominating—the Creation and the Last Judgment. As you look about, you become aware of another painting on a side wall. It is by an artist named Perugino and is titled *The Delivery of the Keys*. The work was completed in 1482, ten years before Columbus discovered America,

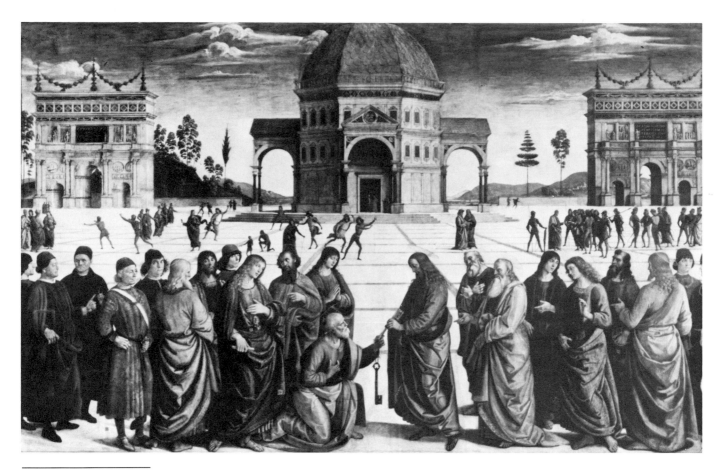

Pietro Perugino. *The Delivery of the Keys,* 1482. Sistine Chapel, The Vatican, Rome.

Although Perugino's painting may seem an unlikely choice as the work of art from which to devise a series of drawing lessons, the graphic concerns of the artist were the same as many facing artists and students of art today.

and it, too, deals with discovery, but discovery of a different sort. As a matter of fact, nearly every important discovery about art that had been made by artists at that time can be found in this single painting.

Although you may never have seen this painting, and it may look different from the paintings of today, there is much that can be learned from it.

[The slide is then flashed onto the screen.]

TEACHER So what we are going to see in this painting is an illustration of almost every important idea that artists had developed at that time. Let's see if we can discover what these ideas were, how Perugino used these ideas and how we might benefit by learning to use them, too. Look very carefully at the slide projection of the painting and tell me what appears most interesting and unusual to you.

STUDENTS Wowee, whistles, hummms, etc.

STUDENT The blocks or squares of the sidewalk.

TEACHER What's so unusual about them?

STUDENT They go back and get smaller in the distance.

TEACHER Ah, yes. Do we have a yardstick here? Let me show you something (takes yardstick; points out the various lines leading to the single vanishing point).

STUDENT It's like an illusion!

TEACHER What else?

STUDENT The way the tree is done.

TEACHER Do you think trees actually looked that way?

STUDENTS (a chorus of yesses and nos)

TEACHER I think that the answer is both yes *and* no. Do you think that trees in Italy are the same as in the United States?

STUDENTS (more yesses and nos)

TEACHER When I look at this tree I know precisely what kind of tree it is. If you go to Italy or Spain you can see them around cemeteries. It is a cypress tree and it represents eternal life . . . so the trees are a little like you would see, but they are also done in the style of the time. If you look at the background of Leonardo daVinci's *Mona Lisa* you will also see trees that look like that—in the style of the time. Now what else?

STUDENT Well, the clothing . . . they're all wearing robes . . . the shading . . .

TEACHER Yes, look at the way they're shaded. You see the incredible shading of light and dark . . . so it really shows folds. Okay, what else?

STUDENT It really looks real.

TEACHER Okay, but what helps it to look real?

STUDENT The sense of the area . . . and the depth . . . like you can see the mountains small in the back and the people.

TEACHER Alright, now look, you're getting on to the part that I was really hoping you would notice. Let's do some measuring for just a moment. We look at that figure [in the foreground] and it is about twelve inches. Now look at these figures back here [middle ground], and do you know how high they are?

STUDENTS (various guesses) $2\frac{1}{2}$, 3, etc.

TEACHER Yes, they are about three inches high . . . and then we go back here . . .

How many figures can you draw in a crowd? Both diminution and overlap were used, not always consistently. Nevertheless, the principles were being learned, thanks to Perugino.

STUDENT . . . Yes, because they are further away.

TEACHER Have you ever noticed that?

STUDENTS Yesses!

TEACHER Now, we know that you don't really get smaller when you get further away, but figures appear smaller when they are in the distance. Now look at these [higher on the picture plane].

STUDENTS (guesses, $\frac{3}{8}$, one inch, etc.)

TEACHER They are about an inch . . . and look at these. They are about 1/2 inch. If there were a figure back here by this mountain it would be about . . .

STUDENT . . . a sixteenth of an inch.

STUDENT It's interesting how he got the proportions just right so that it looks realistic.

TEACHER Yes, look at all the things he does. Look at how he shows heads. This one is from the side; this one is almost straight forward; this one is from the back. So heads are tilted up and down . . . and if you look at the hands, are they all the same—the way we do them? No, every one is doing a different expressive thing (some of the students begin to move their hands in attitudes to mirror those in the painting). So the artist has looked at things so carefully . . . look at these figures in the background; they are just absolutely beautiful in the way in which they show action. I wish I could move so beautifully; they are like dancers.

STUDENT Yes, and one is kneeling down.

TEACHER Yes, and he is shown sort of from the back. Oh (noting the time) if we keep talking we won't get any work done!

Lessons from Perugino

The students' discussion included talk of vanishing points, of space and diminution, trees and shading, the attitudes of figures, expressivity of heads, of hands and of movement, thus setting the stage for the development of a series of lessons based on the painting. Some of the lessons are based directly on the very graphic, thematic and ideational concepts with which Perugino worked; others have been suggested by the picture itself. The lessons are not presented in any set order, nor should such an order be implied. Choices may be made according to preference, interest and student level; and additional ideas may be suggested by those presented. These lessons have been developed and tested with various art teachers and groups of students.

Crowds of People

Figures are essential to the composition of the painting, particularly the grouping of the figures and the manner in which they overlap one another.

Ask students to draw a crowd of people. Let them list situations in which crowds of people are found, emphasizing figures that are close, in the middle and far-off. Have them imagine what the crowd might be like. What are the people doing? Are they quiet or boisterous, active or inactive? Are they close together or standing or sitting apart from one another? Are they in small groups or in a single mass? Talk about and demonstrate overlap.

This crowd of people rushing to a free circus was drawn by a fifth-grade student after a discussion of Perugino's *Delivery of the Keys*.

This far more elaborate drawing on the same theme was made by a secondary school student.

These figures in action follow the concepts of diminution found in Perugino's painting.

Creation of imaginary situations by the students is an important element of a good lesson. Science fiction writer Ray Bradbury says that imagination is our most valuable and perhaps least tapped resource. The free flow of imaginative ideas from one student to another enables each to generate many more ideas and to produce an individual and unique image.

Variations: Crowds may be drawn with or without emphasis on diminution. Issue a challenge: who can do the largest number of overlapping figures—ten? twenty? fifty? one hundred? Pose a group of students as the figures appear in the painting; the class may then draw from these models.

Drawing Figures in Action
The figures in the middle ground of the painting demonstrate a variety of actions; they gesture and posture; they run, kneel and stretch their limbs. A model might assume one or more of these poses as the class draws.

Variations: These might be fast poses of three or four minutes. Poses may be as short as a few seconds' duration for *gesture drawing*. Project a slide of the painting; allow each student in turn to assume one of the poses seen in the painting and then to draw the pose as it felt to him or to her.

An Imaginary Building
The church in the center of Perugino's painting was based on Alberti's plan for an ideal church. It is an imaginary building.

Discuss with the students Alberti's reasons for imagining the church in that way. Compare this church with some of the very real but fantas-

tic buildings of Gaudi in Spain. Have the students carefully study Perugino's church and imagine ways in which they might change it to suit their own fantasies. Point out the major features of the building—the domes, the arches, doors, windows, porticos and columns. They might then construct an imaginary building using these same elements in arbitrary ways: doors and windows may proliferate; angles may become curves; sizes may stretch or shrink; people may appear at windows and doors.

These are only a few suggestions for imagination exercises, but there is no limit to the mental gymnastics that the mind can perform. Some variations might be to draw a building using only arcs and circles or a building using only a straight edge.

How Many Kinds of Trees Can You Draw?

The students found the trees in the painting to be unusual. They are certainly more elegant and decorative than those seen in the everyday world. Perugino's trees appear to be a combination of memory and imagination. This becomes an exciting pattern to follow.

Ask students to draw as many kinds of trees as they can. This is an excellent way to expand their graphic vocabularies. Begin by pointing out shapes and varieties of trees in the painting, and then ask students to imagine as many different varieties as they can. Students who have difficulty inventing new varieties of trees can arrive at solutions by simply altering or extending a tree form that has already been drawn. Have students fill a large sheet of paper with small images or have them create an imaginary landscape with their new forms. Use as reference the work of artists who "created" their own tree or plant forms such as Henri Rousseau.

Drawing Heads and Hands

As the students viewed the painting, they noted various positions of the heads of the subjects, some seen from the back, or in profile, in three-quarter view, tilted upward and downward. Most students can draw only a few head positions at best. Perugino's heads present fine models for expanding skill in drawing heads and portraits; however, profile and three-quarter view and tilted heads are more realistically lessons for the older student. By using the model of Perugino's heads, a pattern may be devised to show the proportion of features to head and the location of eyes, nose and mouth.

Hands are also subjects for junior high school and high school students. Although fifth graders were fascinated by the hand positions in Perugino, even imitating these with their own hands, they would almost certainly find the drawing of hands a thoroughly frustrating task. Sometimes younger children can draw heads and hands with remarkable skill, but most often articulation of these features is best left to the older child. Older students often become amazed at their own ability to produce quite masterful contour drawings of their own hands in a variety of attitudes.

Placing Oneself in History

The eight hatted figures in the front row—without halos—are actually portraits of Perugino's contemporaries. They are citizens of the fifteenth century who have been painted as though they were witnessing an event some fifteen hundred years earlier. Rather a neat trick if one can bring it off; and children *can* bring it off through the magic of drawing.

You can play a game with students reminiscent of a once popular radio show called "You Are There." Have the students place themselves in any period in history, real or imagined. They can land at Plymouth Rock with the Pilgrims, fight at Custer's Last Stand or Napoleon's Waterloo, join Noah on the ark or Luke Skywalker in space. These lessons can be as simple or as complex as time, ability and imagination allow; they can be executed as individual drawings or large class projects.

The list of lessons from Perugino could go on and should, but our purpose here is only to suggest the range of projects that might be developed from a single work of art.

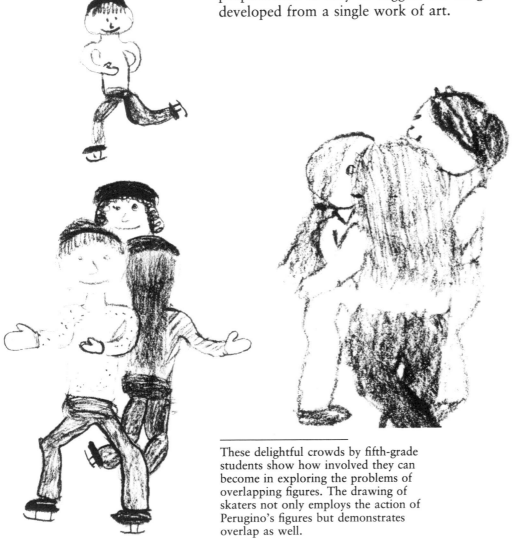

These delightful crowds by fifth-grade students show how involved they can become in exploring the problems of overlapping figures. The drawing of skaters not only employs the action of Perugino's figures but demonstrates overlap as well.

A Lesson From David: Our Own Marat

The following lesson was taught by Michael Organ, an art teacher from Wales. His emphasis in the lessons from David was on the ideational rather than the technical aspects of drawing. Here, in fact, the students worked from the same subject matter as did the French artist David. They were not shown the painting until after they had completed their drawings.

Mr. Organ read to his 12-year-old students an account of the killing of Marat in Paris in July 1793 from *On Trial: A Revolutionary's Revenge*. The three-page account begins with a description of the "dignity and beauty of the slim, red-haired girl" Charlotte Corday, who stood trial for stabbing the 50-year-old Marat to death in his bath. It told how the revolutionary Marat had prepared a list of 300,000 men, women and children said to be enemies of France, and how Charlotte, a former revolutionary herself, decided to prevent the killing of these thousands by ridding her country of Marat. This ugly and deformed patriot had contracted a skin disease while hiding in the sewers of Paris, and the irritation from this malady was so severe that he was obliged to spend his life immersed in a tub of water. After the class had read the entire account of the death of Marat, they were asked to visualize the most dramatic portion of the account:

> *The words were scarcely out of his mouth before Charlotte had snatched the knife from her dress and sunk the blade into Marat's bare chest. His dying cries of murder brought his servants—and then the police—into the room. Charlotte was arrested, taken to a cell in the Prison de l'Abbaye, and asked why she had committed so bloodthirsty an act.*

Following the reading, the students were invited to visualize and then draw their versions of the episode. It was only after they had completed their own drawings that they were shown Jacques-Louis David's painting, *Death of Marat*. Both the similarities and differences are striking.

These six drawings by Mr. Organs' students show the range of abilities among twelve-year-old students. They also show how emotionally involved each has become with Charlotte Corday's stabbing of Marat. Two of the drawings (opposite page) show several distinct events of the story in a single frame. The drawing above shows what must surely be one of the most dramatic knife plunges ever "recorded." The last two drawings depict a panoramic view and a dramatic close-up.

Although the drawings of the students exhibit a great diversity, they also reveal an intense involvement with the violent political act of 1793.

When the students were asked to write about the differences between David's approach and their own, it was obvious how sensitive their own drawings had made them to David's painting as well as to the possibilities for visual expression. Dianne wrote:

> My drawing of the death is completely different from David's because my drawing shows the actual death, when Charlotte Corday stabbed him. The painting by David doesn't show the actual murder. His painting shows Marat as a good looking young man. The real Marat, according to the story, was an older man with a skin disease he caught down in the sewers. I like the painting because it is very realistic. I don't like it because he doesn't show the real murder.

This drawing of the *Death of Marat* contrasts markedly with David's painting. Its composition and expressive quality owe more to comic books than to the Neo-Classic mode in which David worked.

Like Dianne, Lawrence commented upon David's glorification and idealization of the death:

> The picture I drew after reading the story was different to [sic] the real painting. Mine gave the impression of horror and real life but the painting by Jacques-Louis David seemed to take out the horror and ugliness of it. The bath seems more like a bed. My picture shows the room as it [was] described yet David's is centered on Marat.

Carl's comments show how vivid his imaginative recreation of the scene was:

> The picture created in my mind was an overhead view with blood everywhere, e.g., over the books, in the bath water and all over him and the murderer running away . . . I thought the ink and quill would have been knocked over and blood on the board that he was resting his book on, and water scattering across the room, but on J.-L. David's painting, just painted it from the side and there was hardly any blood, just the mark that the knife made and there was no sign of the woman who murdered Marat. You could not see any sign of a struggle and it looked as if he had let her stab him in the chest. His murderer could not have run away because she probably had a big awkward basket under her dress.

Mr. Organ has taught similar drawing lessons using the historical events associated with Gericault's *Raft of the Medusa* with results that are just as interesting, including, he adds, "a preponderance of images from the film *Jaws* which was showing at the time."

Through Mr. Organ's lessons, his students are learning about the subject matter that has stirred artists and motivated some of their greatest works. The same subject matter inspires students to produce emotionally-charged drawings. Furthermore, the comparisons between students' and artists' depictions of the same subject matter involve students in a task very much related to art criticism. And basing instruction on key works from the history of art is an effective way to teach both drawing and art history.

There is no lower limit to the age at which students are able to work from works of art. Kari, a 5-year old, drew a self-portrait based on Ensor's *Self-portrait with Demons*. Kari's demons seem benign, although the hat with the green plastic eye-shade she was wearing the day of the drawing contributed to the uniqueness of her portrait.

James Ensor. *Self-portrait with Demons*, Color Lithograph, 1898, 21″ X 14 11/16″, Museum of Modern Art, New York. Ensor's self-portrait suggests that students' self-portraits might be surrounded by their "demons," their fears, their hopes, their dreams.

ANGEL HOLDING
CROWN OF
THORNS 1667-1669

Sculptures make excellent objects from which to study the effects of light and shade. The problem set for the high school student who drew the Egyptian head was to use tone to create form. This careful drawing took four hours to complete. The angel, on the other hand, took only a few minutes.

After dividing her paper into quarters, a 14-year-old was instructed to choose a portion of a painting, no larger than 2″ X 2″, from the work of Fernand Leger exhibited at the Albright-Knox Art Gallery. The selected portion was then rendered in one of the four sections. In each of the remaining sections the values were changed, while still using the original composition.

A 17-year-old student was instructed to divide paper into nine sections and to choose any painting in the Albright-Knox Art Gallery to "rearrange" as desired.

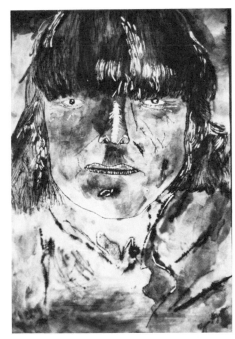

Like drawings, paintings and sculpture, photographs also provide excellent drawing sources. This sepia drawing by a junior high school student was made from one of Curtis' 19th century photographs of American Indians. It captures the feeling in the photograph, not just its realism.

Edvard Munch, *The Cry*. Lithograph,
1895, 13¾″ x 9⅞″. National Gallery of
Art, Rosenwald Collection.

Going For Style: Using Art to Achieve Expressive Character in Drawings

Whatever his genius, the writer unfamiliar with the highest effects possible is virtually doomed to seek out lesser effects—John Gardner

Drawing includes the development of style—an arrangement of lines and forms designed to produce vividness and intensity in a work. Although children in a particular culture assimilate the style of the drawings of other children in that culture, borrowed features are generally limited to the shape of objects, the arrangement of parts and the way space is depicted. Expressive features of style are less prevalent.

A few children go a step farther and learn to draw in the style of artists. But the artists from whom they learn are comic book artists, advertising artists and illustrators. The literal messages of these popular media are usually conveyed through subject matter, action and the narrative rather than through the expressive qualities of style.

In fact, the culture seldom provides the opportunity for students to learn *about* and *from* the styles of artists such as O'Keefe, Rauschenberg, de Kooning, Klee, Munch, Frankenthaler and Picasso. All these artists make the fullest use of expressive qualities of media and form—qualities that give their works vividness, intensity and coherence.

One of the most prolific artists of the 20th century, Pablo Picasso, had a distinctly individual style. But before he had developed his own style, Picasso had assimilated the collective artistic styles of the West, from the Renaissance through Post Impressionism; and even his unique styles were frequently based upon sources such as classical and tribal art, or the works of artists such as Velasquez, Cezanne and Renoir.

In fact, working in the style of artists may be the best way for

students to learn to draw in a uniquely personal way. And at the very least, working in the style of artists can help students to acquire a taste for the qualities of artistic style.

Working in the Style Of . . .

Even when not explicitly requested to do so, children can easily work in the styles of artists. And the suggestion that students alter the stylistic character of their drawings can bring some astonishing results.

The Inescapable Mood of *The Cry*

An offset reproduction of Edvard Munch's lithograph, *The Cry,* was made for each student in classrooms of third- and sixth-graders. They were given information about the artist and the time in which he worked. The students were then asked what they thought was happening in the picture, and how it made them feel. Their impressions were of fright and anxiety. The eerie quality of the sinuous, undulating lines, the expression of terror on the face of the central figure and the tension between the central figure and the two figures in the background all had their effect.

After Munch's *The Cry*. When stylistic models such as Munch's lithograph are vivid enough, even kindergartners, when asked to treat the print as part of a picture story and to draw "what happens next," take their cues from Munch's style. This version by a first-grade student is filled with expressive lines. Some especially in the lower left corner are much like those of Munch.

A third-grade student concentrates on the terror of the figure, but still emulates the undulating, Munch-like lines of the sky.

The undulating lines of the print are transformed by a fifth-grade student into sharp geometric lines. In the process of borrowing, students exert their own stylistic viewpoint.

The students were asked first to imagine and then to draw their version of what might happen next in the picture. In their extensions, even the third-graders drew in the style of Munch, although they had not been instructed to do so. They felt intuitively that an extension of the action of the work also called for an extension of its expressive qualities. But there was little that could be called mere mimicry of Munch's style.

Variations: The following is a list of artists whose style is so vivid that, like Munch, they provide powerful models:

Willem De Kooning (Woman I, Woman II, etc.)

Pablo Picasso & Georges Braque (Analytic Cubism)

Joan Miro

Georgia O'Keefe (stylized landscapes; closeups of flowers)

Richard Estes (Photographic Realism)

Roy Lichtenstein (Pop, comic-strip illustrations)

Umberto Boccioni (Futurism)

"The Cry of the Tamany Tiger." An eighth-grade boy combined a study of the connecting rhythms of Munch's painting with the three-quarter view of a tiger based upon Nast's famous cartoon of the Tamany Hall tiger.

Stylistic Variations on a Portrait

For this lesson, postcard-size reproductions of portraits by artists such as Renoir, Daumier, Leonardo and Sully were given to a class of sixth graders. The children were told: "When an artist draws from the work of another artist it may be to learn a style—to make shapes and lines the way another artist does." They were also told that they would paint or draw variations of the work of others, just as artists sometimes do. A sheet of 12x18 inch paper was folded into eight sections; and this assignment was written on the board:

1. Draw the portrait as accurately as you can.
2. Draw the portrait using heavy lines, as heavy as you can make them.
3. Draw the portrait using quick, squiggly lines.
4. Draw the portrait emphasizing shading and shadows.
5. Draw the portrait so that it looks stretched-out from top to bottom.
6. Draw the portrait so that it looks very fat.
7. Draw the portrait so that it is filled with patterns and designs.
8. Turn the portrait upside down and draw it again, or if you wish, draw it as accurately as you can from memory.

Approximately five minutes were given for each drawing and all eight drawings were completed during a 50-minute period. The teacher might demonstrate on the board what a "squiggly line" and a "stretched-out" portrait might look like. The students' capacity for altering expressive qualities is as great as, or sometimes greater than, the teacher's ability to make suggestions about the kinds of lines or qualities that might be produced.

Portrait variations. Most students, left to their own devices, tend to avoid experimentation with expressive possibilities. But when asked to do so, they are able to shift easily from one expressive quality to another. These portrait variations by fifth-grade students were made from postcard-sized reproductions of a portrait by Thomas Sully, Leonardo's *Mona Lisa,* and a Daumier drawing. It is important to view these drawings not as finished products but simply as exercises devised to teach students about stylistic and expressive possibilities.

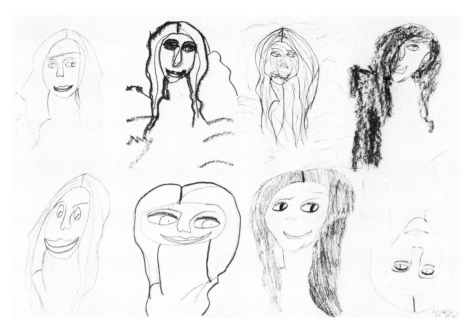

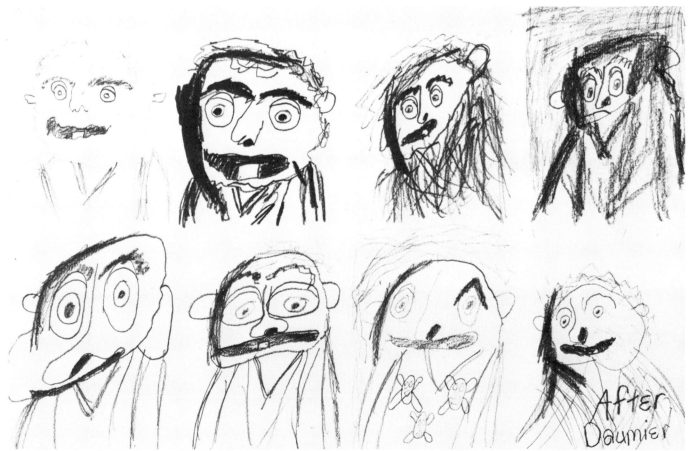

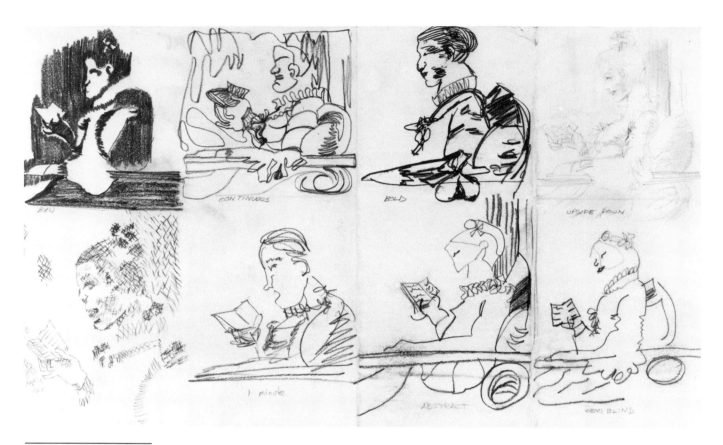

In playing with stylistic variations, this university student simplified the values to black and white in the first variation, and then went on to make contour, cross-hatched and abstract versions as well as one drawn with eyes closed.

Variations: For older students, the possibilities for variations are endless. These might include using:

One continuous line.

Only short straight lines (edge of cardboard strip with watercolor or ink).

Diagonal lines (also, as above or use a comb).

Spiral lines.

Shading in only 2 values; 3 values.

Dots (with pencil point, brush, fingertip dipped in paint or ink).

Lines that follow the form (cross-contour).

Geometric shapes.

Any of the above in white chalk.

Variations on Steinberg's Variations

Saul Steinberg frequently plays with stylistic and technical variations in his drawings. In a single drawing, for example, he might draw one figure with nothing but tiny dots, another with tiny irregular closed shapes and a third with meandering squiggles. After viewing several of his drawings, sixth-grade students could easily describe the techniques that Steinberg used to achieve his stylistic variations.

One student was posed before the class; and students were asked to

draw the model using very quickly drawn scribbly lines. For the second pose they were to draw as if the figure were made of rocks, "like a rock wall." In the third pose the drawing was to be constructed of short straight lines "going every which way." The final pose was to be drawn using horizontal lines placed closely together (a favorite Steinberg technique), and students were shown that as they placed some of the lines close together, they would achieve the appearance of shading. Although style and technique were the major elements of the lesson, students were reminded to look closely at the characteristics of the model and to try to capture the feeling of the pose.

Such lessons sensitize students to the qualities of drawing styles. Development of their own styles comes much later.

Students are delighted by Saul Steinberg's playful approach to stylistic variations within a single drawing. Here, a sixth-grader has produced variations from a series of seated and standing models. Even primary grade students can produce these types of variations. Another drawing shows that the exercise has application for high school students as well.

Straight-line Portraits in the Style of Steinberg

Primary grade children are able to perceive and produce stylistic features almost as readily as older students.

First graders were shown several portraits composed almost entirely with straight lines from Steinberg's *The Inspector*. Some of the drawings showed "speech" balloons, but the "words" emerging from the mouths of the people were simply geometric shapes and lines. Using a yardstick and chalk on the board, the teacher demonstrated how a portrait could be drawn using only straight lines, "just as Steinberg does." The first graders were given rulers and pencils and asked to draw characters such as soldiers, nurses, movie stars and policemen using nothing but straight lines.

Variations: Drawings similar to Steinberg's straight-line portraits can also be made by providing students with small pieces of cardboard which they dip into tempera paint or India ink and then draw by stamping with the edge of the card. Students might be given rubber stamps consisting of letters and symbols to use in their drawings, such as Steinberg often uses.

Similar variations might be made by using Feininger's geometric architectural and cityscape drawings as models.

After looking at and talking about Steinberg's portraits from his book *The Inspector,* first-grade students had little difficulty working in the manner of the artist. Heather, like other kids in her class, was intrigued by the abstract lines and shapes designating "speech" coming from the mouths of Steinberg's portraits. Like the artist, she produced her version of this geometric language.

These abstractions by fourth-grade students also had Steinberg as their source. Drawn and stamped with pieces of cardboard dipped in ink, these works walk the narrow line between drawing and printing, just as many of Steinberg's works do.

Saul Steinberg frequently achieves the unique character of his works through a combination of drawn lines and patterns made with small rubber stamps. These drawings by third-grade students may not have the sensitive and elegant lines of their Steinberg predecessors. Nevertheless, the lines, stampings, and the characters themselves attest to an awareness of stylistic possibilities.

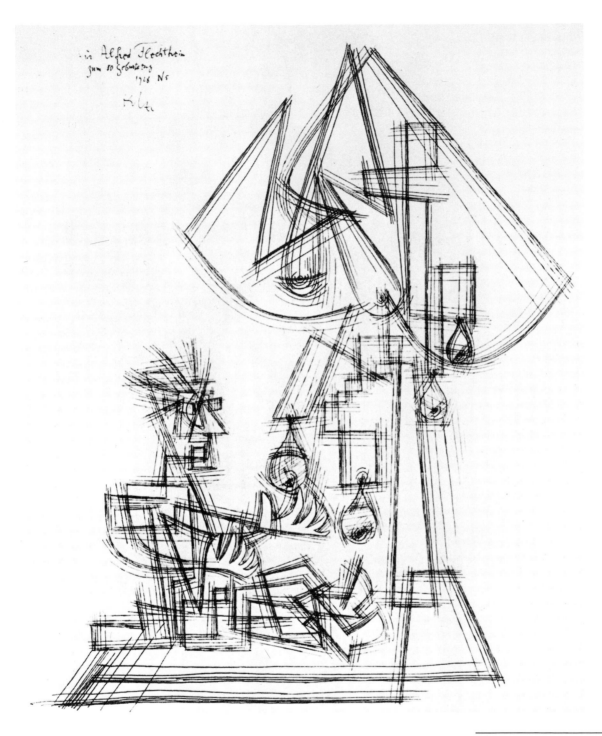

Paul Klee, *Portrait of Flechtheim*. Drawing, Pen and Ink, 1928, 11¾″ X 9¼″. E. Weyhe, New York. This drawing vibrates with the energy of the boxer and punching bag. Klee's use of multiple lines to show movement has many applications for students' work.

After talking about the effect of the lines in Klee's drawing ("like a guitar string moving"), students, ages five to seven, drew the bumpiest, jumpiest, most vibrating thing they could think of.

Francisco Goya, *El Aquelarre*. The Prado, Madrid.

The Sinister World of Goya

Late in his life, when he had become deaf and isolated from his beloved country, Spain, Goya produced a series of *Black Paintings,* portraying covens of witches, crones, demons, goats and the like, all huddled together. These paintings are so heavy and dark that they look as though they might have been painted with a mixture of tar, blackstrap molasses and molten lava.

Children looked carefully at these paintings and listened enthusiastically to tales of Goya for clues to why he might have made such paintings. But when it was time to make their own Goya-like drawings, no coven of witches or even a large number of children was available to pose. Instead, each class member (including the teacher) posed in turn, wrapped in a length of cloth and wearing their most witch-like expressions. To further capture the mood of the Goyas, the room was darkened except for a single spotlight which highlighted the features of the models in mysterious ways. The coven was made of a series of these posed figures, drawn overlapping and side by side.

Large black wax crayons were used to help produce the sinister tones of the *Black Paintings*. The drawings were then covered with turpentine to dissolve the crayon and blur the edges.

Conclusion

Three important points become clear from the ideas and lessons in this chapter:

1. Style develops as the artist attempts to achieve some larger artistic and aesthetic end. The development of style requires rigorous work, directed not only toward the achievement of a personal style or even the assimilation of a more general cultural style, but toward the production of aesthetically meaningful works of art.

After looking at and talking about slides of Goya's "Black Paintings," eight- to eleven-year-old students took turns posing. Each of the models wrapped in a "shroud" and made a sinister face. As each new "witch" posed, the figure was drawn in black crayon alongside those drawn previously. When the last figure was drawn, a turpentine wash was brushed over the wax lines to achieve qualities that even Goya might like.

Presenting these exercises in the techniques and processes will help students to achieve the *look* of style and expressive quality. As a result of these exercises, students will not necessarily produce stylistically meaningful works of art. They may, however, start to understand the function and production of style in art.

2. Even the youngest students respond to style, and when stylistic models are vivid enough, students reproduce them intuitively in their drawings. The consequences of a K-12 articulated art program centering on style are not known. It is possible that students in such a program would begin to produce style and expressive qualities as if by "second nature," and knowingly resort to stylistic means for desired effects in their drawings. But such programs will have to be established before we can be sure.

3. Finally, there are certainly ways other than the presentation of stylistic models to evoke stylistic and expressive qualities in student drawings—for example, assignments in which ideational, emotional, feeling and thematic aspects are vividly characterized.

Students can become easily sensitized to aspects of style in art. It is important to teach students to knowingly produce stylistic and expressive qualities on their own, and the best guides to the achievement of a personal style are the works of artists that provide us with a vision of the range of possibilities.

Cubist portraits. Sometimes the concepts associated with particular styles, although simple enough to understand, are difficult to produce. As practiced by Braque and Picasso, the Cubist style of painting had two distinctive features: the transformation of shapes into facets and planes, and multiple views of a single object. The seventh-grade student who drew the full-face head had no difficulty drawing facets, but could not portray multiple views. But, in a first-grade class that had just studied Picasso's portraits, the girl who drew the seated figure not only depicted the head from multiple points of view but even achieved a bit of cubistic angularity in body and chair.

An 8th grader used Jan Gossaert's (Mabuse, detail at left) use of cross-hatching, then applied this technique to a portrait of his father.

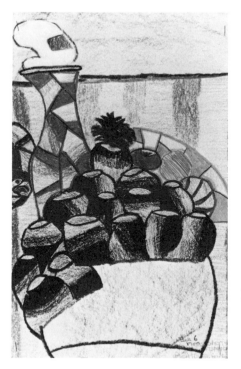

This crayon drawing of still life objects uses both the subject matter and the techniques of the style. The seventh-grade class in which it was produced had been studying Cubism.

Concentration!

Observation: A Program of Drawing from Life (Still and Otherwise)

Exactness is not the truth.—attributed to Matisse

Many students assume that to draw well means only to draw with great accuracy. Popular illustration, photography and the strong emphasis on visual realism in the graphic world of young people influence them to be faithful to a model. To equate good art with visual realism is an attitude shared with the Ancient Greeks, and one that seems to have continued virtually unaffected by the modern movement toward abstraction and expressionism. And yet a drawing that is merely a faithful rendering of what the artist has perceived may be sterile, lifeless and devoid of artistic vitality.

As art teachers we know that good drawing encompasses much more than careful looking and accurate rendering, but it would be foolish to ignore this cultural bias toward visual realism. Remember that observational drawing skills may be used as the basis for expressive, abstract, experimental and imaginative drawings. Observational drawing should be one of the central features of a school drawing program from kindergarten to twelfth grade.

Chapter 2 discusses our natural graphic tendencies: to use the most simplified and undifferentiated forms possible, to draw objects from their most characteristic views, to avoid overlapping objects and to use our own well-established repertoire of configurations rather than to develop new ones. These tendencies limit our untrained drawings and must be overcome if we are to attain visually realistic renderings.

Traditionally, observational drawing involved a lengthy regimen of painstaking drawing from plaster casts, teaching students to delineate every subtlety of form and contour, as well as nuances of light and shade. Careful observation and drawing persisted in the ubiquitous still

life and, eventually, the life model. Through this exacting process, students effectively overcame their intrinsic graphic biases. They learned the discipline of drawing.

Without turning the art classrooms of the country into quasi-art academies, the very best ingredients of the traditional observational drawing programs can be incorporated into art classrooms. Accurate observational drawing can be achieved by students if teachers understand and follow these few simple pointers:

Students should include graphic detail in their drawings when salient information about a model has been pointed out to them.

If students are frequently asked to draw from unfamiliar objects (rather than from objects for which they have already developed drawing patterns, habits and programs), they will tend to produce more observationally accurate drawings.

If techniques such as contour drawing are taught, students will increase their observational skills, and their natural graphic inclinations toward simplicity and non-differentiation may be short circuited.

If students are shown the observational drawings of artists while doing their own observational drawings, they will gain drawing skills through the observation of both actual models and graphic models.

A K-12 Program of Figure Drawing

Although figure drawing is sometimes thought best reserved for the secondary school student, the proper place to begin is with the kindergartner. Also, drawing from the figure should not be viewed as simply a unit to be conducted once during the year and then ignored until the next year. Because observational figure drawing skill increases little by little, a properly conceived art program should intersperse figure drawing with other activities. In some instances figure drawing might even be conducted in five or ten minutes before or after another art project. Thus students who finish a project should be encouraged to draw from a model (either one that has been posed or from other students working in the classroom) while others finish their projects. They should also be urged—even required—to carry sketchbooks with them in which they may draw people in the street, on buses, in the library.

Figure Drawing in Kindergarten and the Early Grades

Since many young people tend to develop a single schema for drawing a person which persists with little variation, observational drawing will help to increase the number and range of their schemata.

Kindergarten children were given a 9x12 inch sheet of paper folded into quarters. The children were told to look very carefully, just as an artist does, to see how the four individually posed models (two children and two adults) were different from every other person in the world. Before beginning to draw, the students discussed with the teacher the

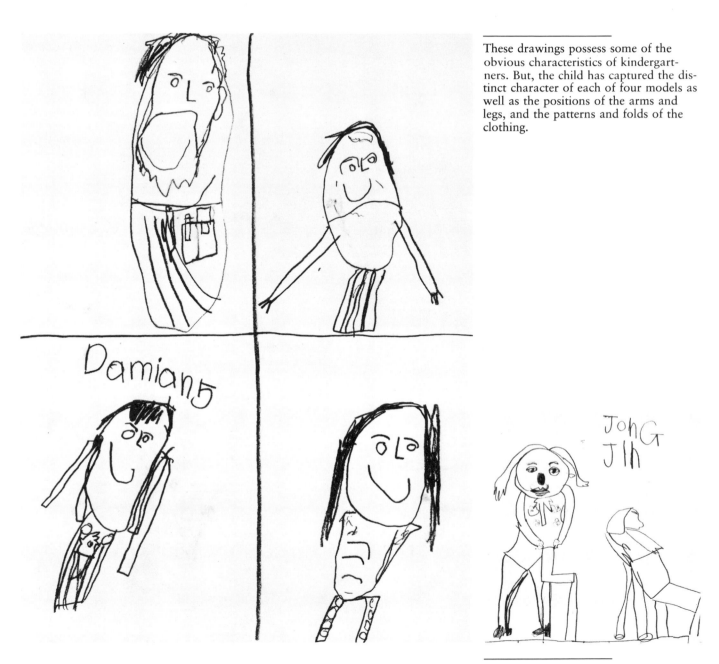

These drawings possess some of the obvious characteristics of kindergartners. But, the child has captured the distinct character of each of four models as well as the positions of the arms and legs, and the patterns and folds of the clothing.

Jong Jin, age five, has drawn the same model from two different points of view. Pointing out the characteristics of poses can easily modify children's tendencies to draw figures and objects from only one point of view.

By presenting the model in an unusual way, students must observe more closely than usual. In these two drawings by sixth-grade students, a Stuart Davis painting projected on the posed model has altered the visual qualities of the model and produced results beyond the student's customary drawing habits.

characteristics of each model. Is the face long and thin, square or round? Is the hair long, short, dark, light, straight, curly? Does the shirt have a pattern? What shape is the skirt?

Even the first figure drawings by kindergartners show a good deal of differentiation and a likeness to the characteristics of individual models. With continual practice they can achieve amazing skill in capturing the character, detail and pose of the model.

Figure Drawing in Middle and Junior High School Grades

The straightforward approach to figure drawing described above can be used at any grade level, but unusual approaches to figure drawing are more challenging and exciting.

Model with a Projected Image

Placing a model in a different setting, surrounding the model with unusual props or even superimposing images on the model, forces the students to observe the model with increased concentration. In this case a seated model posed on a table in front of a projection screen while a slide of a painting by Stuart Davis (with the words "ELSE" and "NOW") was projected across the model and onto the screen.

Sixth-grade students were asked to draw everything they saw—the pose of the model, the features and especially the patterns of light and color from the projected slide which traced contours across the figure. This approach was certainly complex and yet the results were astonishing.

In this drawing by an older student, the shadow caused by the projected painting becomes an alter-ego figure.

Models dressed in costumes can make figure drawing almost irresistible. The costumes, like slides projected on models, present elements for which students have not developed previous drawing strategies. Close observation is facilitated when the features of the costumes and the models are pointed out in detail before the drawing begins.

Dressing up the Model

Dressing models in unusual ways can have almost the same effect as projecting images over a model. Students might be dressed in costumes—as pirates, magicians, kings, sheiks, detectives. But why stop with just costumed models. A script can be written, and a unique cast of characters posed in a tableau.

Unusual Settings

For a change of pace, it is exciting to place models in highly improbable settings. One model might pose on top of a nine-foot stepladder, another climbing the ladder and more models clustered below in extreme poses. Such arrangements provide the opportunity not only to observe and draw figures from different vantage points and in different action positions in the same picture, but also to draw figures that overlap ladders and one another.

In one figure drawing class, a model in a crash helmet complete with curlicue wires and flashing lights reclined amid an enormous dump of bicycles, boxes and barrels.

Why not combine costumed models with novel settings by creating a tableau based on a famous painting. Produce a version of James Ensor's *Intrigue,* Van Gogh's *The Potato Eaters,* the foreground figures in Honore Daumier's *The Third-Class Carriage,* Jan Steen's *The Eye of St. Nicholas* and Rembrandt's *The Blinding of Sampson.* Students can also be posed in the positions of figures in any artwork—painting, drawing, print or sculpture—without the benefit of either costume or prop.

Re-created scenes add excitement to the figure drawing program. Sixth-graders staged a mock struggle at the base of a ladder, which provided a striking structure, even if there was no room in this composition for the boy perched at the very top.

Drawing from the Figure in the High School Years

Many students, particularly in advanced classes, will wish to acquire the traditional skills of life drawing at this time. And here figure drawing can more fully adhere to the traditions of the art school. Although it is hardly reasonable to expect the majority of high school students to have the opportunity to draw from the nude model, this obstacle to providing a life drawing experience can still be circumvented. One successful high school figure drawing class used as models the large number of students involved with dance and the performing arts. These students posed in leotards and tights. Because of their dance experience, they were able to take innumerable wonderful poses, to change the pose every few minutes for fast gesture drawing, and to hold a single pose for long periods of time. Those who were drawing from the model were able to discern and articulate the important contours and in many cases to ignore the burden of the clothing in order to produce some accurate and sensitively drawn figures.

Gesture Drawing

Drawing from plaster casts was the traditional training for artists. More recently—after Kimon Nicolaides—the trend has been more towards a loosening-up than a rigidifying process. The "new" tradition, then, begins with quick gesture drawing, where sometimes a single line may capture the feeling of the pose. This type of drawing need not be restricted to older children and has been done very successfully with even eight-year-olds.

This exercise ideally requires large amounts of paper, preferably paper that is easily acquired and expendable. Newsprint, discarded newspaper, or brown wrapping paper may be used, and many drawings may be made on a single large sheet, either individually or overlapping one another. In this way, many drawings can be produced quickly and students do not consider each drawing to be precious.

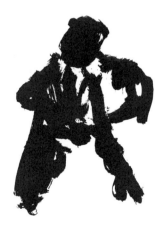

In these brush and ink gesture drawings done by eight-, nine-, and ten-year-old students, the emphasis was on capturing the essence of the pose. A large bamboo brush discourages students from placing much attention on detail.

Each pose is taken for only as long as it takes most of the students to draw the continuous line that describes the movement and the attitude of the pose. Then the pose is changed, again and again, until the student can easily "feel" the pose with the drawing tool (a large crayon, graphite, conte crayon, charcoal or brush and ink). Some of the best references for gesture drawing are Daumier, Rembrandt, Kley and Lautrec.

Contour Drawing

The movement of the drawing tool on the paper in slow contour drawing has been described by Nicolaides as that of "an ant climbing a mountain." In fact, when properly executed—often "blind," or without looking at the drawing but only at the figure—the students are able to perceive more detail and to draw as though on a glass that has been placed between themselves and the model. This heightened perception and careful drawing of every contour and form tend to allow the student to bypass remembered schema and other habits that sometimes inhibit good drawing practice. Again, even young children can practice contour drawing to some extent.

Both the pose and the point of view are important, and in this figure drawing, each forces the student to concentrate on foreshortening. Other point of view possibilities are to position the model above or below eye level.

This sensitive contour drawing by a senior high school student shows the effect of practice. This level of skill need not be unusual for high school students if they draw frequently from the model.

The traditions of figure drawing are extremely varied—from the soft smoldering subtlety of a Pascin to the blatant slickness of the pinup girl. Students should follow their inclinations as these high school students have. But high school students are sometimes so in awe of a smooth rendering that they ignore other techniques. They should also distinguish between the various approaches to figure drawing and try their hand at various types. Figure drawing from the nude model is not usually available in most high school art classrooms. These drawings were made from models clothed in leotards. When the lines of the leotard are not drawn the figures look much like those done in a life class.

Presenting students with shading techniques such as those employed by artists promotes a successful figure drawing program. The artistic precedents for this model's lighting might have been set by Caravaggio, Latour and Rembrandt. In this drawing by an Advanced Placement student, detail has been subordinated to the broad patterns of light and dark.

The Posed Model

With younger children, the emphasis in drawing from the model is on novelty and playing with unusual possibilities in order to create confidence and to eliminate stereotypical notions of drawing. With the high school student the teacher can play upon the desire for realism. Here the work of fine artists can best be utilized to show students the use of light and shade (Rembrandt, Carravaggio, Vermeer); of foreshortening and point of view (Mantegna, Tiepolo, Rodin); distortion, elongation and expressionism (El Greco, Gauguin, Beckmann, De Kooning). And one should also use as a resource the very best fashion and commercial illustration.

The Portrait

In the history of art, the portrait reigns supreme. Even within the United States there exists a complete range of these works, from the childlike drawings of the early limners to the psychological portraits of Thomas Eakins. Nothing satisfies (and challenges) the high school student more than drawing a self-portrait in which they can incorporate what they know of the world of art and artists and reveal as much of themselves as they dare.

An important lesson can be learned by doing a second drawing from the same pose or by drawing from another drawing—while changing the medium. This pose was drawn first in charcoal from the model. Then a second wash drawing was drawn from the first. Try working one pose through a series of media that might include charcoal, pencil, pastel, oil and turpentine, watercolor on wet paper and a stick dipped in ink.

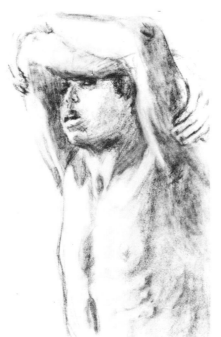

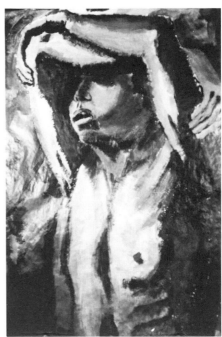

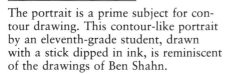

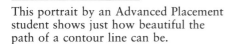

TITLE: DRAWING
MEDIA: INK
ARTIST: GAIL BAUM
GRADE: 11

The portrait is a prime subject for contour drawing. This contour-like portrait by an eleventh-grade student, drawn with a stick dipped in ink, is reminiscent of the drawings of Ben Shahn.

This portrait by an Advanced Placement student shows just how beautiful the path of a contour line can be.

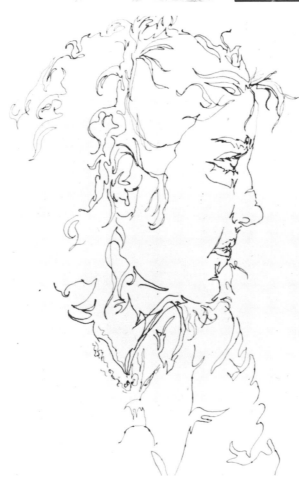

There is more to drawing a portrait than merely getting a likeness. These two portraits each show, in their own way, how the expressive use of media can take the portrait beyond the realm of superficial likeness. These portraits by high school students appear to probe the depths of character.

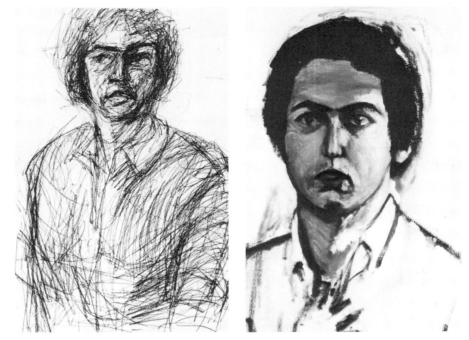

Self-portraits might include much more than the face, and they might be made from an unusual reflecting surface. These high school students drew themselves as reflected in Christmas tree ornaments. The hands holding the ornaments add a striking dimension to these portraits that seem like mysterious distorted visions of innerworlds. The unique quality of the drawings results in part because they were made with ballpoint pens.

Drawing from Objects

Drawings from individual objects that are small enough for the student to handle or to be placed on a table are often highly detailed and intriguing. Objects that are unfamiliar to the student provide some of the best observational drawing training.

Masks, Bronzes, Carvings and Plastic Toys

Five- and six-year-old students were invited to select and draw from a collection of African masks. They drew at least three masks on a page; when one mask was finished, another was selected. As the children drew from a particular mask they were continually reminded of its unique features. Occasionally the children were encouraged to draw a mask from the side rather than the front view.

We sometimes give children a single object such as a bronze figure or more accessible plastic figures of animals and people. They draw a single object several times, each time from a different point of view. Even children of six and seven years can draw horses and polar bears from the front and from above with quite remarkable results.

Young children are sometimes considered to be incapable of drawing what they see; it is thought that they only draw what they know of something. However, when children as young as five are asked to draw unfamiliar objects, they learn to see the unique character of the objects. These drawings from African masks were made by children ages five to seven.

Observational drawings are frequently more accurate if students closely examine the objects that they are to draw. And they can also gain a flexible attitude toward point of view if they are asked to draw the objects from an unusual angle.

Bill, age ten, achieved an unusual sense of volume as he rotated and then drew from an Indian bronze sculpture.

Jason, age five, did almost as well with his drawing of a Benin bronze figure.

Even when children draw from unfamiliar objects, a personal style is apparent. Five-year-old Kari, for example, whether she drew from an African bronze of a crocodile eating a man or small wood carvings from Spain, produced bold, sure lines and a distinct pattern of black and white.

Think of the variety of small objects from which students might draw. Michael, age five, drew these animated drawings from small plastic horses. Jong Jin, also age five, drew from small plastic toys inspired by *Star Wars*. Before Jong Jin began drawing, he was asked to observe the bent knees and elbows of the toy figures.

Drawing actual tractors and motorcycles provides a marked contrast to drawing small bronzes and plastic toys. These vehicles were drawn by fourth through sixth graders. The motorcycle rider was added after the cycle was drawn from observation. See how much more detailed the observational part is than the non-observational.

Tractors, Bikes and Bones

Not all objects suitable for drawing are easily placed on tables and turned about at will. At one school tractors and motorcycles were driven into the school yard and drawn throughout a school day by various classes. Or why not carry in the skeleton and plants from the science room? Articles of clothing, too, hung from lines or pinned to walls make excellent objects for drawing.

Almost any object or setting is suitable for an observational drawing—a skeleton borrowed from the science room, a deer skull, plants in the school greenhouse or a shirt hung from a line in the art room.

This highly conventional, yet superbly executed still life by a fourteen-year-old Russian boy illustrates that an ordinary still life set-up can dampen an unusually skillful handling of technique. We might, however, take a lesson from art education in the U.S.S.R.; occasionally our students should be expected to spend several hours on a single drawing.

The Lively Still Life

The still life arrangement consisting of a random collection of old bottles, driftwood and dried weeds lives up to its name. In these assemblages "life" is so still that it is aptly described by the French word for still life, "nature mort" or dead nature, and their ordinariness makes drawing more a chore than a challenge. It doesn't need to be that way at all. For example, a teacher from the High School of Art and Commerce in Ottawa, Canada, produces thematic still life arrangements that are themselves works of art. Think of unique thematic possibilities—astronauts and space exploration, tools, baseball and other sports, ancient Japan, a surrealistic tabletop, colonial America, the eye-deceiving effect of a William Harnett wall assemblage, the American Indian.

An art teacher at the Commercial High School in Ottawa, Canada, goes to unusual lengths to collect and arrange objects for still life set-ups. Each has a theme: Victorian times, cameras, etc. Notice how a mirror increases the complexity of each arrangement. The set-ups are so beautifully selected and composed that they seem to invite drawings to be made with unusual sensitivity.

Unique Approaches to Still Life Composition

The usual approach to the composition of the still-life is to frame the outer edges of the arrangement just within or slightly beyond the edges of the drawing paper. Quite another problem is encountered, however, when students are asked to draw only a portion of the arrangement, to draw the still life from an unusual point of view, or even to draw segments of the arrangement from different vantage points.

You might give the assignment to draw only a four-by-six-inch portion of the arrangement. Empty slide mounts and small rectangular frames cut from paper may be used to select compositionally interesting portions of the arrangement. In short, students are asked to find and draw mini-compositions from within the larger composition of the still life arrangement. These segment compositions often have an abstract character that is very different from the original arrangement.

A single still life might be drawn from three vantage points. Students can begin drawing from the left side, move to the right side and superimpose portions of the second view upon the first. Place the subject on the floor for an aerial perspective. Finally move to a central position and superimpose for the last time. Patterns created by the overlapping forms might be emphasized through value changes to create still life abstractions. This exercise could lead to an introduction to the cubist drawings of Braque and Picasso.

The inclusion of unusual objects in a still life arrangement inspires drawings with intriguing meanings. The doll and the prize ribbon in this drawing by an Advanced Placement high school student lead the viewer to puzzle over the possible symbolic connections of the juxtaposed objects. The composition with objects placed only in the lower half of the picture plane adds to its subtle power. Courtesy Educational Testing Service.

The typical approach to a still life arrangement is simply to draw everything, fitting the objects comfortably within the boundaries of the paper. However, these two drawings by Advanced Placement art students incorporate only a small segment of the arrangement. Part of the attraction of these drawings is that none of the objects can be identified; yet, we are encouraged to attempt to recognize the unrecognizable. Courtesy Educational Testing Service.

These still life arrangements of cylinders and stacked paper cups, reminiscent of Morandi's set-ups, have been transformed by eight- and nine-year old students, so that they have a Morandi-like monumentality about them. This effect is achieved, in part, by placing the objects well above the students' eye level. In the second set of drawings the students were instructed to draw only the spaces between the objects.

From Still Life to Concepts of Composition

The Italian painter and printmaker Giorgio Morandi is one of the finest still life artists of the 20th century. His modestly sized compositions of ordinary bottles, pitchers and other assorted containers are imbued with a quiet power and presence that makes small bottles appear as monoliths. The power of these compositions derives in part from the interplay between patterns of dark and light. It was with Morandi's still life compositions that a group of eight- and nine-year-old students began their own exploration of the power of light and shadow. A group of geometrically-shaped objects (display blocks, paper cups, cylinders, etc.) either painted white or covered with white paper were placed above eye level on a large white cube against a black background. A strong light was then focussed on the entire display. From this the students were asked to make three separate progressive drawings: a line drawing, then a shaded rendering in pencil, and a drawing with only the area around the objects described in heavy black charcoal sticks. Through this kind of still life project, students can move from the task of depicting the character of an arrangement to the exploration of concepts of composition. Both tasks are very much a part of drawing the still life.

Conclusion

Observational drawing is at the very heart of learning to draw well. Although there are many aspects of drawing that cannot properly be classified as observational—imaginative and inventive drawings, for

In a variation of the Morandi-like still life drawings the students were asked to darken the spaces around the objects.

example, are not necessarily derived from a model placed before the artist—virtually every drawing, whether from memory or imagination, owes at least something to previous observation and delineation. Therefore many of the exercises outlined in other chapters of the book will be based at least partially on observation—observation of spatial features and objects in space; of motion, action, and expression; and of the qualities of works of art and photographs.

Still life arrangements seem to call for slow drawing in accurate detail. Occasionally students need to draw quickly, taking liberties with the array. In this spontaneous drawing, the objects are depicted both from eye level and below eye level.

In the "visual task" approach to drawing built forms, students are asked to combine real with imagined elements. In this ink drawing by a fourteen-year-old British boy, the buildings are much as they might appear, while the poses of the people and things such as the clothesline hanging across the street are imaginative extensions.

Working From Built and Natural Forms: Another Approach to Drawing

Seeking to improve their powers of observation, artists have traditionally confronted the world around them. Cave dwellers worked from memory and used their impressions of other humans and animals to create images that ranged from symbolic to realistic. The artist-apprentice of 15th century Italy helped his master-teacher to dissect the human body to uncover the secrets of anatomy. By drawing objects, people and forms from both the natural and the man-made world, artists sharpened their powers of analysis. They discovered how things *worked*, and they used this information to proceed from description to feeling, from transcription to speculation. They could, for example, use the information gained through the drawing of existing buildings to develop plans for new structures. Whether it was the design for a home, a civic building, a park or a monument, the artists' ideas were first set down as drawings. Since drawing permits flexibility and change, they used drawing as a means of thinking about a problem. Make a sketch and you can begin to solve a problem: change a line here, add a few lines there, and the solution changes.

Without such graphic statements, we may not be completely aware of what we are thinking.

This section shows how drawing can make students aware of both the built and natural environment by developing their general awareness of structure, design and form. As Keith Gentle, a British art educator, has written:

Drawing can communicate many things more easily than words, for example, shape, texture, pattern, surface, rhythm, relationships and spatial ideas. Visualizing patterns and connections between things, building up an understanding of how they work or fit together is far easier with

Using the traditional approach to drawing outdoors, students can achieve fine results—especially when they search the landscape for interesting details using a rectangular "window" cut from a card.

drawing than with words . . . Children's art . . . can be stimulated by spatial and kinaesthetic experiences as much as visual and tactile ones. The spaces within and between buildings, the solidity of rocks and trees, the relationship between figures and their environment, are often the elements that excite response . . .

The range of responses to the environment will be extended enormously because of these developments and could include the following: at one extreme making scale plans, annotated diagrams and drawings with a technical bias which show different views of the same object and how it fits together and works, and at the other extreme recorded observations, composite views, inventions and drawings which are imaginative, fantastic, or expressive of feeling and emotion.

We will not deal with "fine arts approaches" to studying the environment. This chapter describes how to encourage children to become more analytical and, by moving them away from conventional approaches, to enable them to probe their perceptions more deeply.

Two Approaches to Drawing From Built and Natural Forms:

The Traditional Method

The subject is the rows of houses that adjoin a city park. (The woods behind a school, or even a seemingly barren school ground may provide an equally rich array for drawing.) The teacher begins a high school art class by saying:

Find a comfortable place to sit. Your task today is to draw any portion of what is before you. Be sure to include the natural forms such as houses,

stores and cars. And try to be sensitive to the sizes of objects; notice what is big and what is small and draw them that way. Also pay attention to what is in the foreground, middleground and deep space. Sketch in the basic shapes lightly before you commit yourself to your felt pens. You may use a viewfinder to help you select the composition that most pleases you. If you need help let me know. You have almost an hour, so there should be time for a few exploratory sketches.

This is a typical introduction to an outdoor sketch class of secondary school students.

The Visual Task Approach

The "visual task" approach which follows presents a different attitude toward the same subject. It is actually a complex set of approaches of which the traditional approach described above is only a part. In this scenario the teacher addresses her class on the same location:

Today we are going to try a number of things using the park and the houses as our subject. There are many ways of working from a subject—we can use our eyes, our imaginations; we can rearrange and speculate; we can try to look at our surroundings in new ways. I was here over the weekend, and as I studied the area I wrote down a number of things for you to do. I have typed and duplicated them so that each of you can have your own copy. Obviously you can't accomplish all the suggestions today so we'll come back one more time. I'll read the tasks aloud so that you will understand what I'm asking you to do. Notice that I've put the assignments into categories.

Part I: Observation

1. You know how to do contour line drawings. After studying the entrances of the homes on Blank Street, draw three doorways. Place them next to each other on the same sheet of paper for comparison.
2. Make at least two drawings of people in a loose sketchy manner, not in contour. In one drawing, place your subject in her/his surroundings and remember that the size of your subject can help determine how much of the background to draw. In the second sketch, pretend that the people are in a nudist colony. Keep the pose, the likeness, the gesture, but remove the clothing. We are beginning with observation but we are also using imagination.
3. Study the line of the roof tops as they travel from one house to another. Try a continuous contour line drawing as it moves from roof to chimney to the shape of the buildings behind it. Do several roof contour lines searching for roof lines that differ from each other.
4. Pick a tree that appeals to you and instead of drawing the branches, draw the spaces between them.
5. Choose a car. All of you have drawn a profile of a car or truck at one time or another. This time, draw the back, the front and a three-quarter view.

Studies of doorways and a window.

A fragment of a tree? Well yes and no; it is actually a drawing of the spaces between the branches and the leaves.

Studies of skylines with continuous contour lines.

Sometimes when a series of fragments—in this case, bits of architecture and sculpture—are made on a single sheet of paper, the drawing is far greater than the sum of its parts.

Part II: Imaginative Extensions

1. Draw five squares on a sheet of paper. Then select a tree, a house or an automobile, and in your five frames depict a series of transitions from realistic to abstract.
2. Draw another five squares, and this time transform one object into another—a fire hydrant into an automobile, for example.
3. There is a wading pool at the intersection to our left. Design a monument or some type of sculpture for this area. Do a careful drawing of the pool area so that it is possible to see how the monument fits within the space. As you design this monument, you might first think of an event that it might commemorate.
4. Select the most unattractive building in the area. Draw it as it actually exists, but next add to it something that you think would alter the character of the building completely.

Drawing well and imaginatively depends upon increasing acquisition of visual information and developing skills, plans and programs for transforming that information into graphic form. In the "visual task" approach and the subsequent "imaginative" extensions assignments, students are directed first to engage in careful observation, then to quick delineation or graphic note-taking tasks. Finally the newly developed perceptual and graphic skills are directed toward a series of playful applications. None of these exercises need result in "finished" drawings. Yet some of the most prized drawings were originally made as detail studies for paintings and sculpture. Think of Michelangelo's drawings of feet and hands, for example.

The visual approach can be used in working from the model, still life or almost any other subject for drawing. Drawings and paintings of artists, photographs and other visual materials can also be used. The idea is to develop graphic fluency through continuous practice.

What would it be like if your home town were destroyed? "Historic Downtown Bethlehem, Pennsylvania?" is what the bent sign reads. But the remains are from the Parthenon. The feeling of desolation of this imagined destruction is enhanced by the strong horizontal bands countered by the vertical columns. An implied triangular shape begins with the fragments of columns in the lower middle ground and recedes column to column to an imaginary point at the left side. But perhaps most striking of all is the figure that is the focus of attention. This drawing, like the others shown in this chapter, were made by university students majoring in either elementary education or art education. The students were asked to pay special attention to the compositional aspects of their drawings. Students of almost any age might be asked to pay attention to some aspects of composition—such as close-up and long shot. The conscious arranging of smaller shapes into coherent larger shapes should probably wait until the secondary grades.

Composition for Meaning and Expression: Beyond the Principles of Design

"Anyone who can learn to write can learn to draw;" and everyone who can learn to draw should learn to compose *pictures.*—Henry R. Poore

Isn't it true that everyone who draws pictures also composes them? True, but there is both unconscious intuitive composing and carefully considered conscious composing. To compose is to employ both in arranging the components of a picture in order to achieve desired structural, meaning, expressive and aesthetic effects.

The traditional art educational approach to teaching composition takes students through a series of exercises relating to elements such as line and shape, and then through exercises involving principles of design such as unity, rhythm, proportion, balance, subordination, center of interest, etc. In fact, so much emphasis has been placed on the elements and principles of design that they have frequently become the principal content of art education. As important as design and composition might be to art, they are only means, not ends in themselves. Rather than allowing the tail to continue to wag the dog, a problem or task approach to composition should be considered in which design serves only as a means to reach larger artistic and aesthetic goals.

A Total Approach to Composition

The following project is based on Picasso's *Guernica* (and the series of over 60 drawings, studies, and other works relating to the mural). In addition to composition, it involves a whole range of expressive, stylistic, symbolic, sensory, formal and aesthetic considerations.

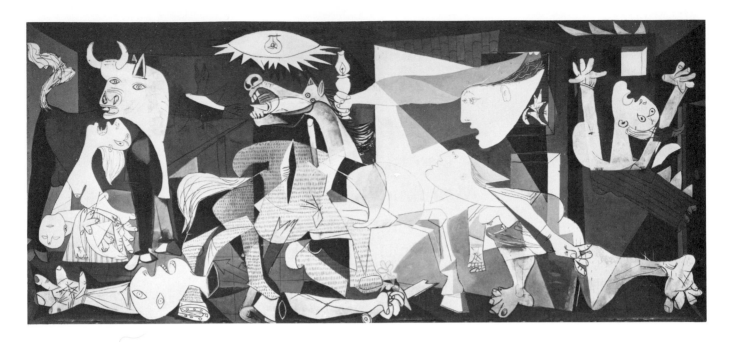

Pablo Piccaso. *Guernica*, 1937. Oil on canvas, 11½′ X 25½′. Prado Museum. Madrid. Copyright ARS, NY/Spadem 1987.

Guernica Bombed: My Town Bombed

Before studying *Guernica*, we give the students some background on Picasso's commission for the mural, followed by the reading of the *London Times* account of the bombing:

The year was 1937 and Spain was engaged in civil war. Although the Spanish artist Picasso had lived in Paris since 1904, in his art he had shown his opposition to the fascist forces attempting to control his native country. In January of 1937, the Spanish Government in Exile commissioned Picasso to paint a mural depicting the war's devastation of Spain. It was not, however, until May 1, five days after the ancient Basque town of Guernica was bombed, that Picasso made his first sketches for the mural *Guernica*. The *London Times* account of the destruction read:

> *Guernica, the most ancient town of the Basques and the center of their cultural tradition, was completely destroyed yesterday afternoon by insurgent air raiders. The bombardment of the open town far behind the lines occupied precisely three hours and a quarter, during which a powerful fleet of areoplanes consisting of three German types, Junkers, and Heinkel bombers and Heinkel fighters did not cease unloading on the town bombs weighing from 1000 lbs. downward and it is calculated more than 3000 two-pounder aluminum incendiary projectiles. The fighters meanwhile plunged low from above the centre of the town to machine-gun those of the civilian population who had taken refuge in the fields. The whole of Guernica was soon in flames except the historic Casa*

de Juntas, with its rich archives of the Basque race, where the ancient Basque Parliament used to sit. The famous oak of Guernica, the dried old stump of 600 years and the young new shoots of this century, was also untouched.

The bombing of Guernica presaged the even more horrible destructions that later befell the cities of Europe and Japan, and can still remind us of the capability humans now possess to destroy all of civilization. The horrible destruction of the town and Picasso's painting have become nearly fused as one cautionary event.

Following the reading of the *Times* account of the bombing, students are asked to imagine the destruction of their own home town. Their own imaginary destructions and our ensuing discussions of these devastations help to sensitize them to a whole range of *expressive, stylistic, symbolic, emotional, sensory, formal, personal and general* features that an artist might consider. For instance, a student may focus on the loss or destruction of personal possessions. This might *symbolize* the loss of the things that tell us individually who we are. "Black clouds and grey dust all over everything" refers to *expressive qualities;* "the looks of terror, fright, and sadness on the faces of the fleeing victims" refers to *action, literal and emotional aspects* of the imaginary event; the descriptions of "piles of rubble" refers to *composition.*

Compositional Considerations

We then ask students to draw what they had imagined. Ask what they wish to draw (the fright, the chaos) and how they feel they can best *organize (compose)* their drawing to show the things they have imagined. Careful reference to the factors an artist might consider in drawing a violent or emotionally-charged picture invites consideration of how compositional factors can help make an expressive and meaningful work of art. And what are those factors? A partial list follows. (With young children you may work on only one or two compositional factors during a drawing assignment. With older students, who have already been introduced to the factors, you may refer to most or all of the factors as they compose their drawings.)

Size, Shape, and Orientation

Some of the first decisions to be made in starting a drawing relate to the paper or other drawing surface. Why not teach students to alter the size and proportions of their drawing paper to fit the size and shape of their idea? Then the decision is not left to the manufacturers of drawing paper. And we should not have to remind students to think about whether their drawing will be oriented vertically or horizontally. A study of Picasso's drawings for *Guernica* reveals that he experimented with a variety of papers in different sizes and proportions.

Distance or Location

Important considerations are: "How far away will you place the subject?" or "how close is the implied viewer to the scene? Would a *close-up*, a *medium shot* or a *long-shot (a panoramic view)* work best? Or

could you combine a close-up with a panoramic view? Can you think of some other combinations?" In this age of cinema, video, and comic books, even young children easily grasp these important compositional ideas. You might say to them, "Imagine that your head is a camera and your eyes are the lenses. How close or how far away do you wish to move your camera?" But, although they may easily grasp the idea of long-shot and close-up, students may still need to be shown the way to make things appear close or far, simply by changing the size and position of objects or shapes in relationship to one another.

Cropping

One of the most effective ways to make things appear close is to draw the objects large and have them appear to extend beyond the frame or edge of the paper. Students will find cropping to be an effective compositional device. However, because of one of those inborn biases outlined in Chapter 2, students frequently avoid overlapping one object with another in their drawings. Consequently, they are also reluctant to allow shapes or objects to be "cut" by the sides of the paper. Works by Degas and Lautrec are excellent illustrations of compositional cropping. Photographs also illustrate how artists compose pictures by allowing the shapes to "extend" off the page.

Point-of-View

Another important consideration in creating a composition is point-of-view. Ask, "Will you show the things that you have imagined at *eyelevel, below or above eyelevel,* from the *front, side, back,* or even

How do you depict destruction from below? This solution shows a close-up view of the bottom of one foot appearing to be drawn upward in a tornado-like force. This single human fragment symbolizes much more than the demise of one individual. The strong horizontal shape of the foot is nested within swirling concentric circles.

from a *bird's-eye view or an ant's-eye-view?''* Or they might want to try the very difficult Analytic Cubist method ('invented' by Picasso and Braque) to show multiple sides of things simultaneously. One good way to practice shifts in point-of-view is to have students redraw one of their already completed drawings from an entirely different imagined point-of-view. The converging lines of perspective drawings discussed in Chapter 11 are important when students begin to draw from above and below eye-level.

This composition in which the major shapes are arranged in a semicircular pattern at the top shows a bird's-eye view. The amorphous lines that fill nearly two-thirds of the space open to make a nest for a listing of the cultural monuments lost in this destruction.

Placement

Other questions pertain to the placement of objects or shapes in the drawing. "Will you place the important objects or shapes in the middle of your drawing? At the top, bottom, on the left or right, on both sides, at both the top and the bottom, arranged in a somewhat orderly way around the page? What other kinds of arrangements can you think of?"

Considerations of placement need to be coupled with the principle of balance—the relative visual weight of one shape to other shapes or to the sides of the paper. Although much has been written about design and the necessity for all pictures to be visually "well" balanced, some of the best artists have demonstrated that purposely "unbalancing" a picture can powerfully alter the expressive content. The work of Edgar Degas illustrates the principle of "occult" balance—a balance created through visual cues rather than objects. In many of his works from the ballet, for example, several dancers on one side of the canvas are "balanced" by a single figure on the other. The weight is provided by lines, both actual and implied, that point to the lone dancer. The important thing is to understand the aesthetic and expressive consequences of creating different kinds of balance and "unbalance."

Take a well known painting such as *Washington Crossing the Delaware* and play around with the composition by placing a sheet of tracing paper over it and moving it around so that relationships are changed. How would the painting look if the boat were placed lower on

This destruction floats in black space. The overall rectangular shape made by the collection of smaller shapes follows the edges of the paper.

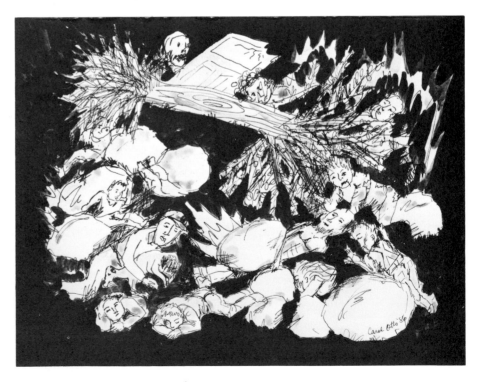

the canvas, or higher? Suppose Washington's position shifted to the right or to the left? Can you defend the artist's choice of placement?

The Shape of the Shapes

One of the most interesting compositional devices, although difficult to understand and to control, is a way of configuring shapes within a picture to form a larger shape. The shapes within Paul Cezanne's still life paintings, for example objects such as a bowl and fruit, were arranged so that together they formed a triangle or pyramid.

The shapes in a drawing can form a triangle sitting on its base to show stability (as Cezanne's did) or a triangle sitting on one of its points to show instability. Think of some of the possibilities: (1) a cluster of shapes to form a circle placed in the middle of the picture, or a large ring of shapes close to the sides of the paper or even extending beyond the paper in places; (2) shapes organized into horizontal, vertical or diagonal bands; (3) horizontal and vertical bands of shapes that cross at a variety of points, each with expressive consequence; (4) shapes that form a radial pattern, an S-curve, an L-shape, an oval. Think of the ways all these larger shapes formed from smaller shapes might be combined.

These shaped collections of shapes may be used to form the so-called compositional "center of interest." But students should know that pictures need not have a center of interest or that one picture might have several.

This scene of destruction places strong emphasis upon the symbolic and emotional dimensions of an actual flood experienced by this university student majoring in elementary education. She combines a close-up view of the triangular victim seen in the lower right corner with a panoramic fish-eye view of the buildings organized on a circular baseline. The large head on the right is symmetrically balanced by the collection of heads on the left.

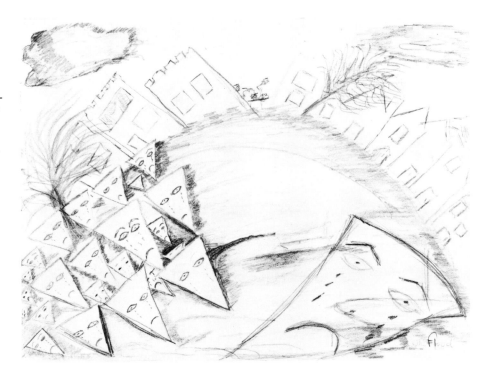

When students are asked to pay special
attention to the relationship between
composition and meaning, their draw-
ings frequently acquire a vivid expressive
quality. The horizontal oval collection of
victims in the upper half of the composi-
tion appear almost to have transcended
the plight of those in the vertical oval
shape below. Together these two oval
shapes form a diagonally oriented trian-
gular shape balanced on its apex that is
cropped slightly at the bottom.

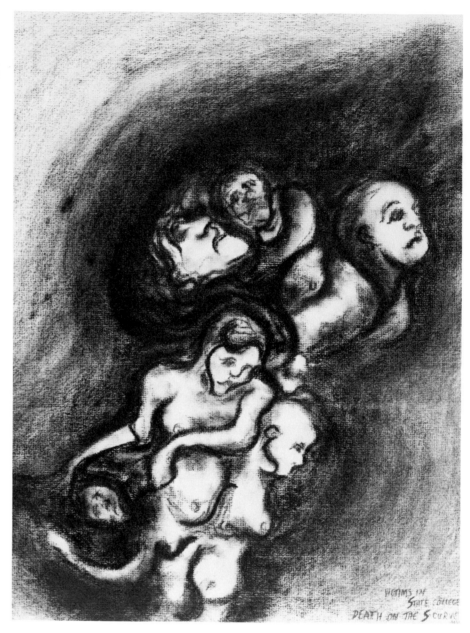

This student composed her drawing with a strong diagonal element. The large figure on the left cowers below a white diagonal band containing partly human, partly tree-like shapes, below an ominous sky in which the sun is nearly blotted out. Specific compositional assignments such as this help to sensitize students to the compositional features of works of art by others.

Compositional sensitivity seems lacking in our students. In a National Assessment exercise in which students were asked to trace around two seemingly obvious triangular shapes in a painting of a madonna and child, less than 10% of seventeen-year-olds were able to indicate these major features.

The Principles

The usual principles of design frequently found in art instruction—rhythm, harmony, emphasis, subordination, dominance, variation, etc.—should not be forgotten altogether. However, some of the other ways to think of composition provide a more comprehensive and more workable system than the principles of design. Nevertheless, it is easy to see how these principles might be combined with the factors set forth in this chapter. By attending to distance or location, point of view, placement, cropping and orientation, students may more easily see the relationships between the structure they create within their picture and the way the picture expresses and symbolizes meaning. Composition is, after all, only a means to achieve a larger meaning.

Conclusion

There are dozens of systems of design and composition. The preceding pages have sketched only some of the possible additional approaches to composition. And remember, composition is not something to be "mastered" before students begin drawing. It is an integral part of the drawing process—of every drawing we make.

The eyes have to travel over each part of an object before it can be drawn accurately from memory. One effective method is to write about a work. Students were given these instructions:

First, write a complete description of the drawing. Try to describe the placement, character, texture, values, technical features, expressive quality, etc. of every line, every shape in the drawing. Metaphoric, analogic and expressive language can help to characterize the things that you see. Your descriptions and characterizations should help you to remember the drawing in detail.

Second, put aside both the drawing and writing, and without looking at either, make a drawing of the drawing from memory.

Here is just a small excerpt of what one student wrote about Picasso's *Study after Guernica:* "The head of the grieving person is positioned on the left-hand side of the paper starting about a sixteenth of the way down the paper. Above it all the way across the paper is a pale wash of watercolor, palest just above the hair. To the extreme left there

is a medium to dark gray veil that is sort of stuck flat to the head of the griever. There are lines running diagonally through the veil . . ."

After she made the memory drawing she wrote: "I was forced to closely examine even the minute details that my mind would have otherwise skimmed over. But I also realized that doing the work from memory was not as easy as I had anticipated. It was hard to remember the exact positioning of some of the parts of the body and the drawing came out somewhat distorted."

Drawing from Memory

If I were to run an art-school I should take a tall house, and I should put the model and the beginners in the top story; and as a student's work improved I should send him down a floor, until at last he would work upon the level of the street, and would have to run up six flights of stairs every time he wanted to look at the model.—Edgar Degas

The capacity to store and call upon information is a critical factor in all artistic professions. A dancer must memorize literally hundreds of bodily movements linked to sounds and rhythms. An actor preparing for King Lear calls upon a lifetime of practice so that word sequences can become a part of movement and vocal projection. Conductors and opera performers must retain a complete repertoire of compositions.

Artists develop a visual vocabulary of forms, shapes, subjects and objects. It is from this memory bank the artist can think, plan and project ideas onto a sheet of paper. This chapter deals with how we can strengthen our ability to retain the forms of the things we see.

All drawing, with perhaps the exception of blind contour drawing, depends to one degree or another on memory. Young children, who have not yet added observational drawing to their repertoire, rely almost entirely upon memory. And yet, most art teaching pays little attention to this important aspect of drawing. This has not always been so.

In 1886 a little book entitled *Drawing from Memory*, originally written in France by Madame Marie Elisabeth Cavé, was published in the United States. It had been glowingly reviewed by the painter Eugene Delacroix and Felix Coitereau, the French Inspector-General of Fine Arts. Delacroix said, "This is the only method of drawing which really teaches anything." Such a powerful endorsement of method surely merits our attention.

Madame Cavé's book, titled in French *Dessin sans Maitre* (*Drawing Without A Master*), was written as a series of letters to a friend who

was, in turn, to instruct her daughters at home in the art of drawing according to the lessons set forth in the 17 chapters of the book.

Madame Cavé's method contained three essential parts:

1. A piece of sheer gauze stretched over a frame was placed in front of the subject to be drawn—a scene, a person, a still life. While looking through the gauze, the young person traced the subject beyond with charcoal on the surface of the gauze.
2. The "proof" (in effect a tracing from nature) was then used as a guide for a freehand drawing of the same size to be made on a sheet of paper. The student was to check continually to assure that the drawing was correct, that it contained the same proportions, vanishing points, foreshortening, etc. as the proof.
3. In the third step, the pupil made a drawing from memory of the drawing made previously from the proof.

In the book, the results of this program, as it was used with students from eight to twelve years of age, were reported by the Inspector-General of Fine Arts to show:

> 1st. A remarkable correctness in the ensemble and contour of a figure or any other object.
> 2nd. A reproduction from memory scarcely distinguishable from the copy.
> 3rd. Acquaintance with the masters; I have readily recognized Raphael, Holbein, and others, in the drawings from memory of Madame Cavé's pupils, and I thus conclude they have for themselves become familiar to a certain degree with the great masters. [The students also made memory drawings from their copies of the masters].
> 4th. Finally, the idea of perspective; that is, that without having learned any of the rules of the science, pupils, in tracing from nature execute correctly the greatest difficulty in the art of perspective foreshortening.
>
> Thus, by exercising the memory of children, giving accuracy of vision and firmness of hand at the age when their organs, still tender, are docile, Madame Cavé renders them better qualified for the industrial professions, makes them skilful instruments in all the trades which pertain to art.

We do not suggest the reinstitution of the Cavé method in the schools. Nevertheless, some essential principles underlie her approach to teaching drawing.

Accurate drawing is based on detailed information about the parts, structure, foreshortened appearance, etc. of the objects to be drawn (the original "tracing from nature" provided this information).

Graphic routines (we might consider these to be mini-programs) are more easily developed when working from a two-dimensional graphic model (tracing from nature, rather than the three-dimensional model of nature itself).

Madam Cavé had her students "trace the world" on gauze stretched over a frame. Windows and acetate make the task much easier, but the lesson is the same. Once students fix images in their minds through drawing from a "tracing," checking, redrawing from memory, checking, and if necessary redrawing again from memory, they become less dependent upon a model.

Graphic programs become firmly established only when they are able to rely on memory, without any models. In other words, all copying, whether from nature or from another drawing, is useful only up to a point and should be discarded as soon as possible. An important key to drawing well and easily is the ability to call upon an immense store of graphic configurations that have been "committed to memory."

Even realistic drawing involves more than simply working from nature. All art learning can draw upon the best art of the past. And, by working from the masters, Madame Cavé's pupils learned about line, composition, shading and expressive qualities from the best art models.

Much of our modern day research on drawing, referred to in Chapter 2, confirms the basic soundness of the Cavé method. Memory is the essence of her program. Some applications suggested by that method for students of all ages today are illustrated in the following projects.

Madam Cavé Updated

We have adapted the Cavé method to the modern drawing classroom. Instead of the frame with stretched gauze, students tape sheets of acetate to windows. Then, generally following Madam Cavé's instructions, they trace onto the acetate the scene in front of them, with the type of marker used with overhead projectors. (Grease pencils may also be used, but less successfully.) Madam Cavé omitted one important detail from her instructions: the eyes must not move from a fixed position during the tracing process. Each little movement of the head presents a slightly different "world" to trace. (Thomas Malton in his 1783 treatise on the history of perspective actually shows an apparatus through which to "sight" while tracing the world.) Some of our students chose to rest their chins on books stacked on the window ledge, while others simply tried to hold their heads still. The initial tracing was then used as a guide for the next drawing. Finally, memory drawings were made based on the memories of the images from the first two steps of the process.

Although the process is cumbersome, it reveals to students both the perspective structure of the world and the power of training one's visual memory. You might enjoy trying a variation of the method with your students.

Memory Drawing from Drawings

Madame Cavé apparently had her students draw not only from their own tracings of the world but also from works of art. Drawing from art is a superb means for training visual memory and for becoming thoroughly acquainted with a work of art.

A variety of methods can assist students in memorizing a work of art. The most simple is to tell students that they will be expected to draw an object or work of art from memory; this motivates careful observation. Allow a few minutes for the study of the work, remove the work and then ask them to draw it from memory. The process might even be repeated two or three times inasmuch as during the second and third

observations students note features overlooked before. Ask students to make either quick or careful observational drawings of works of art as a way to visually memorize features before drawing from memory. One of the rewarding things about memory drawings based upon works of art is that students usually capture the expressive characteristics along with the more literal features.

Begin by memorizing differences between simple, related forms (an orange, a pear, a lemon). Study each form first, then draw it from memory, using a different color pencil for each fruit. Overlap the shapes so that you can see where one form departs from another.

Move ahead from simple rounded types to more complex shapes such as pineapples, bananas or a bowl of overlapping fruit shapes. Apply the same principle to other groups of related objects such as vegetables, crockery and clothing on hangers.

If you were visiting a class in a foreign country, and they knew you were an artist, you would be asked to draw something that reflects life in America. Also requested would be subjects that appeal to them through the impressions conveyed by movies and television such as cowboys, stage coaches, horses and, of course, Indians. How accurate would your drawings be of a cowboy boot or the way a hat fits on a

head? With such objects, you might want to consult the paintings and drawings of Frederick Remington to build your memory bank. Remember, there is no easier way to capture the attention of children—or waiters—in a foreign restaurant than through the use of drawing; truly the international language.

Ask students to draw anything that is a part of their lives (the door to their house, the entrance to the school, the shoes they wear and so on), and they will quickly realize how little information is retained about any subject. Next, ask them to draw the same subject from observation. When the two are compared, they will be notably surprised at the differences. Now inform them that they will be "tested" with a third drawing to see if it is closer to the first or second drawing. Tell them that in two weeks they will be asked to do a memory drawing of one of the reproductions in the room.

An Art Critical Approach

One of the most effective memory exercises is to combine a form of art criticism with drawing. By writing extremely detailed descriptions and analyses of the features of the work (the objects, actions, locations, sensory and formal aspects), the work can become fully fixed in memory. The exercise is a good way to get to know a work of art intimately and at the same time to train visual memory.

Memory Drawing from One's Own Drawings

Although memory drawing from the work of others is important, far more important is drawing from the memories of our own drawings. There are dozens of variations on this memory drawing strategy. One is to have students complete a self-portrait made while looking in a mirror. Then have them make several variations based on the model drawing. Or, as soon as students have completed a drawing of a posed model, ask the students to draw from their memory of the model without referring to their completed drawings. (It is actually the schemata of the first drawing, not the actual model, that "sticks" in our minds.)

Reportage and Memory Drawing

In *Memories of James McNeill Whistler*, T. R. Way, a close friend of Whistler, describes how Whistler would study the essential features of a scene, then turn his back on the scene and review the features in his mind's eye. He would then turn around to view the features again to check his memories. He repeated the process until his memories of the scene were accurate enough to use as the basis for a painting.

The Whistler method can be used as a frequent activity for students of all ages. It works!

Whistler's method might be considered a form of reportage drawing. The term refers to artists (especially before the invention of the camera) who record dramatic events as they are happening. These artists, whether in battle, at a fire or at an accident, sometimes have time to make action sketches, sometimes not. They may have time only to view the event quickly, perhaps from a variety of vantage points. The later drawing is based on memory.

Two examples of contemporary reportage come to mind, both of

One's own drawings are the most important visual source for drawing from memory. Students were given twenty minutes to draw a self-portrait while looking in a mirror. Next they drew at least 50 additional self-portraits based on the memory of the first drawing. Because the remembered images come from subsequent portraits as well as the first, the drawings placed side-by-side trace the metamorphosis of schemata. For variation, students sometimes varied media and techniques. These drawings were made by college students. The assignment, however, might be presented to much younger students.

The personal experiences of children are of limited use without a teacher's ability to develop memory awareness through alerting students to the visual possibilities of an experience. After the event, the teacher must probe the memories of the students through questions which relate to images, impressions and sensory associations. This approach was used by a Taiwanese art teacher of twelve-year-olds who recorded their memory of a shopping excursion.

which—in the absence of the camera—become necessary devices. In the first case, because the camera is not allowed in the courtroom, the drawings of the court reporter record the facial expressions and actions of the judge, jury and defendants. In the second, simulation, it is the memory of similar events that are recorded, as in a plane hi-jacking, space exploration or combat where cameras could not record the action. Reportage drawings, especially those from memory, can synthesize an event in ways that the camera cannot. Here are some reportage-like activities that can enhance the drawing skills of students:

> Explain the meaning of the term reportage-artist and then send students walking through the halls of the school, through the neighborhood around the school, to an athletic event, a play, an art exhibition. Have them draw either one scene from what was experienced or a synthesized view of the experience. The critique of reportage drawings can center on how to best characterize an event. Is the most accurate or the most detailed drawing always the most truthful?

> Present a short video-tape or show a series of slides of the interior of a building (a cathedral, museum, corporate headquarters, etc.), a landscape, a tree, a wrestling match.

> These are exciting materials for reportage drawings in the art classroom. (In his later years, Picasso delighted in watching wrestling on television, and some of the poses and positions seem to appear in his drawings and paintings.) The task for the students is to synthesize the series of views (as opposed to a single aspect of the event) into one drawing or into a series of drawings that characterize or reveal something essential about what they have seen.

Conclusion

Madame Cavé's method provides a reminder of the importance of memory to drawing. And although memory plays a part in nearly all drawing, it must not be assumed that memory will take care of itself. Even students who have had a good deal of art instruction and who may have the ability to draw easily and well anything that is placed in front of them, to record every nuance and fine detail, may be unable to draw any but the most general images from memory. In order for students to exercise the complete range of drawing options, memory-enhancing exercises should be built into drawing instruction at all levels.

Provide students with fragments of photographic illustrations and ask them to plot in perspective the possible remainder of the city. This drawing is by a fourteen-year old Hungarian student.

The Structure of Space

Wow! That's real power!—The comment of a fifth-grade boy upon learning some of the "secrets" of one-point perspective.

In a National Assessment art exercise over seven thousand nine-, thirteen-, and seventeen-year-old students were asked to:

> *Pretend you are standing at one end of a room and at the other end is a square table with four people sitting at it. In the space on the next page, draw the table and the people as you see them from your end of the room. Put one person at each side of the table.*

This simple exercise was devised to determine how successfully students had learned to depict the illusion of three-dimensional space. The drawings were scored based on whether or not students depicted converging lines, overlap, distant objects and figures higher and smaller on the picture plane, and closer figures lower and larger. It was found that only 23% of the nine-year-olds, 42% of the thirteen-year-olds, and 51% of the seventeen-year-olds were able to complete the exercise successfully.

It may be unreasonable to expect more from the nine-year olds, but surely far more than 50% of the seventeen-year-old students should have mastered the basic concepts of perspective.

Although Western cultural style demands that pictures show the illusion of deep space, the culture seems to fail in "teaching" large numbers of young people how to use the basic concepts of perspective. Some do learn perspective by modeling their drawings after pictures and photographs of others. Based on the National Assessment evidence, however, art teachers and classroom teachers apparently have not been teaching the concepts successfully. Yet these concepts are easily learned—some of them by five-year-olds, and all of them by junior high school students. Here are some suggestions for teaching the structure of space, not in a rigid technical way but in a playful and flexible way.

This drawing would have received the highest score on the National Assessment exercise that asked students to draw four people seated at a table. Only half of the seventeen-year-olds in the United States responding to this task could depict the rudiments of perspective.

Learning to Overlap

Of all the factors that assist in creating the illusion of three-dimensional space, overlap is perhaps the easiest to learn. It is very simple to depict one object that obscures part of another. And yet, as we have said, all individuals have an intrinsic bias against overlapping. In the National Assessment exercise "Draw Four People Seated at a Table," only 46% of seventeen-year-old students were able to show figures overlapping the table. And only 17% of the seventeen-year-olds depicted one figure overlapping another. Various exercises are presented throughout the book showing ways to teach about overlap, but it can also be accomplished quite informally.

A Crowd of Elephants

A drawing class of four-, five-, and six-year-olds had been doing observational drawing from highly detailed plastic models of animals. When five-year-old Jason had finished a series of elephant drawings, he was invited to draw anything he wished. He continued to draw elephants, but this time from his imagination rather than from observation. He first drew two elephants spraying one another with water.

The teacher asked, "Why don't you make a whole crowd of elephants having a water fight?" When Jason replied that there was no room on the page for so many elephants, the teacher responded, "Put elephants behind other elephants. Let me show you how." On another piece of paper the teacher quickly drew an elephant much like Jason's and then drew another slightly above and behind. Jason immediately grasped the idea and proceeded to draw seven elephants behind his first two, but not without some difficulty. He sometimes made the lines for the "behind" elephants go all the way round the front elephants. But sensing his own problem, he produced another drawing in which the legs of one elephant properly overlapped those of a second, as the elephants returned to a pool of water to refill their trunks.

Drawing one thing behind another was not a particularly difficult task for five-year-old Jason when he was shown how.

Jason's second drawing of elephants demonstrated an understanding of overlap by drawing elephant's legs one behind the other.

The Structure of Space | 129

In most drawing lessons the teacher has many opportunities to suggest how some objects might be drawn behind others. And when the suggestions are made, students' drawings increase in complexity as they learn to overcome the "don't-overlap" bias.

Steinberg's Parades: Overlap and Diminution

At the beginning of his book *The Inspector,* Saul Steinberg has drawn over twenty pages of a marvelous imaginary parade. Each marcher (drum majorette, American eagle, Uncle Sam, Statue of Liberty, Santa Claus, farmer, astronaut, beauty queen, grim reaper, cowboy, Indian, country western singer, robot, crocodile, and question mark) is flanked by as many as forty overlapping and diminishing clones. By following Steinberg's lead, students can play with perspective just as he does.

Delighted sixth-graders were shown Steinberg's grand parade and excitedly engaged in a discussion: "How does he get so many people in a line?" "How does he make them appear to be behind one another?" "Why does the line of marchers appear to be smaller at the far end?" "Why did he not need to draw the figures repeated in the rear as carefully as the one in front?" "Could you draw a parade like Steinberg's?"

The students were invited to draw any kind of character but were cautioned that their task would be easier if they drew simple figures—even characters derived from Steinberg. Then the teacher illustrated on the board how to draw converging lines, starting at the top of the head and the tip of the toe of their characters. (Here, of course, they were learning about another dimension of perspective, too.) Finally the students were told to begin to draw the diminishing figures. If they wished, those who finished early could draw other lines of figures in their parades.

A sixth-grade student's drawing based on Steinberg's parades of figures.

A Ship of Overlapping Fools

Almost any painting, drawing or photograph that shows overlapping objects can inspire a lesson. Bosch's *Ship of Fools* was chosen for this lesson, as much for its intriguing subject matter as for any other reason. The painting shows a group of "fools" crowded into a small boat. They revel, eat, drink, sing and play. One climbs the mast (a growing tree) to carve meat from a hanging bird carcass; the pilot of the boat joins the party and they proceed to lose their way.

A class of sixth-graders was asked to describe the painting, as well as to explain why the artist depicted rich people, peasants, a monk and a nun as fools and clowns. One explanation is, of course, that while seeking illusory happiness, they forget the precariousness of their existence. This kind of satire is pretty heady stuff for eleven- and twelve-year-olds, but the fact that they did understand was obvious when they produced their own versions of the work.

The assignment was to "think of situations today in which people act foolishly, draw the people in a vehicle, and place as many people in the drawing as you can." Before the students began to draw, a discussion was held regarding the many types of characters and vehicles that might be created: a football team, rich people, the President, robots; and a Cadillac, bathtub, canoe, thimble. Before and during the drawing activ-

Drawing dozens of figures in a small space almost demands the use of overlap. Starting from Bosch's *Ship of Fools* made the task all the more fun.

ity, the teacher repeatedly pointed out that overlapping was one of the easiest ways to crowd lots of people into a small space.

Other paintings filled with crowds of people will serve as models for students' drawings: James Ensor's *The Entrance of Christ into Brussels*, Rembrandt's *Night Watch*, and Bruegel's *Wedding Dance* and *Peasant Wedding*.

Converging Lines and Diminution

Teachers sometimes think that the laws of perspective can only be taught through formal one- and two-point perspective lessons. Certainly these lessons are valid, but students in junior and senior high school sometimes become confused with rulers and rules as they plot horizon lines, right and left vanishing points and the other technical skills required to depict perspective. Putting theory into practice is difficult with the "traditional" method. The laws of perspective are usually presented through a series of diagrams which, when copied, seem to miraculously provide children with a desired illusion of space. But in a real life situation, students encounter problems in applying the generalized rules to what they see.

It is possible to employ playfully some of the basic concepts of perspective. The following exercises serve as an introduction to the concepts of perspective without emphasis on a rigid application of its rules.

A Room in Perspective: Almost By the Numbers

An opaque projector was used to show a Paul Klee drawing of a room in perspective to a classroom of fifth- and sixth-graders. The students were shown how a small rectangle forming the back wall of the room was connected by diagonal lines connecting the corners of a larger surrounding rectangle . These lines formed the floor, walls and ceiling. While the drawing was projected, all the students walked to the back of the classroom and saw that they could observe, in their own room, the same rectangular shape of the end-wall and the converging lines.

When the projector was turned off, the students were told that, like Klee, they were going to draw a room in perspective. But, this time, they

Paul Klee's playful approach to perspective was the basis for these rooms drawn one part at a time by sixth-grade students. Along with the precise directions, students were encouraged to embellish.

would learn step-by-step, much as they learned to do mathematics. The teacher drew on the board while the students followed on their own papers:

1. A half-page size rectangle near the center of the page.
2. A large rectangle near the edge of the paper.
3. Lines connecting the corners of the two rectangles. ("Now you have a room.")
4. A smaller floor-shape (trapezoid), again inside the floor shape. ("Put legs on it and you have a table, like the one in Klee's drawing.")
5. At this point a figure was posed and students were asked to draw that figure in their room, placing the feet near the bottom on the left and the head near the top. Then another figure was posed and drawn on the right side of the room.
6. Students then redrew the same two figures half as big as the first time, and standing behind the first. If there seemed to be too little space, students were shown how they could draw their second figures partially hidden behind the first two.
7. Those students who always seem to finish before the others were invited to shade the figures (there was a single source of light in the room), and to add anything they desired to the room, "surprising things" if they wished. Some added chandeliers, windows, paintings, but more fun were the clowns, jars from which snakes emerged, monsters and corpses which were placed on the table.

The students did an amazing job of producing a room in perspective, thanks to Klee, the step-by-step process and the imaginative added

"bits." Art teachers should take students through carefully guided exercises that are conducted almost solely for the purpose of developing skills in the depiction of space. But playfulness and invention should be included even in the most academic exercises.

Converging Lines of the City of the Dead

The very next time the same students met, they did an even more difficult perspective task. A slide of Cairo's huge cemetery called the "Tombs of the Caliphs" or the "City of the Dead" was projected on a screen. Students were surprised to learn that this pleasant looking "city" was actually a cemetery, and even more surprised to learn that poor people with no place to live had moved into the houses of the dead. The slide was described in detail, pointing out the high angle view, the volumes of the buildings and especially the converging lines of the streets and buildings, "just like the ones we drew in the perspective rooms last week."

Rather than simply saying "draw the city" (which is, of course, what they were soon to do), the students were told to draw one step at a time, as in the room exercise. All students were asked to begin with the building in the lower left corner, the features of the building having been described beforehand. All the students moved on to draw a second and a third feature of the slide. The features of the new buildings to be drawn were always described, with special attention to the converging lines. A yardstick was even placed repeatedly on the screen to illustrate how all the horizontal lines of the buildings seemed to converge at one point, while the vertical lines of the sides of the buildings were parallel.

After several buildings had been drawn one at a time, the students then continued drawing whatever buildings they wished, shading in areas of dark and light where they appeared in the slide.

These drawings are really quite astonishing. Of course, it is easier to draw from a slide than from an actual scene; the students would probably not have produced such accurate and pleasing drawings if they had actually been looking out over the city. Nor would the drawings have been as accurate if students were not led step-by-step. Nevertheless, the students were learning to see and use the underlying principles of perspective, and in the process producing drawings which they valued.

The next progressive perspective lesson took the students to actual settings where they undertook the more difficult tasks of drawing in perspective.

We frequently master a complex task by breaking it into smaller, more easily managed tasks. These complex drawings were made by fifth- and sixth-grade students from a slide of Cairo's "City of the Dead." They are highly accurate in the depiction of space because the concept and skills to be mastered were taken one at a time.

Transparent Cubes

Paul Klee had a flexible attitude toward perspective, using it when suited to his purposes, frequently ignoring it entirely and almost always stretching its rules. To stretch rules, you have to know them, and Klee knew them well. In his small watercolor of 1928, *Ville Italienne,* Klee paints an arrangement of building-like transparent cubes. These large and small cubes pass through and overlap one another to form a city of abstract crystalline brilliance. This watercolor of Klee's was shown to ten- to thirteen-year-old students. A discussion ensued about how the qualities of the painting displayed both the geometric solidity of the transparent cubes and the brightness of flickering light. They were also shown that although the cubes had been drawn with a straight edge, they were actually quite irregular.

At this point a collection of transparent plastic cubes and boxes (such as those used to hold paper clips) were set up in front of the students. Their assignment was to draw a city modeled after Klee, using the transparent cubes and boxes as their guide. They might also present their city from any point of view. Using straight edges, the students drew their cubes showing through and passing through one another. As they continued to experiment with their rulers, they discovered that they could create various effects: hovering high above a city, an explosion of crystals or a city of glass.

These exercises show how the concepts of perspective can be learned without adhering to the formal rules of perspective. And yet, older students should learn one- and two-point perspective. Indeed, when only about one-third of seventeen-year-old students in the United States indicate (as they did on the "Draw Four People at a Table" National

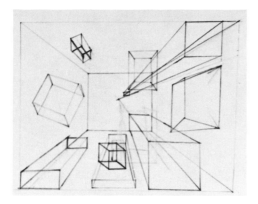

Students' fascination with showing volume is revealed by the frequency with which the "transparent" cube is seen in their random doodles. Partly observational and partly imaginative drawings based on plastic cubes provided entry into crystalline worlds reminiscent of drawings and paintings by Paul Klee.

Assessment task) that they understand the "rule" of converging lines, it seems that it is time for a more concerted effort in teaching perspective. There are numerous books on the subject and each art classroom should have at least one of these references.

Drawing from Different Points of View

Although we often view objects and scenes from above, below and at oblique angles, our intrinsic bias is to draw everything from the front, at eye level. Yet, drawings made from unexpected and unusual points of view are often far more interesting. Comic strip artists discovered this fact a long time ago, but then they may only have been following the lead of the masters, like Tiepolo, Mantegna, Tintoretto and Correggio. Learning to depict objects and settings from unusual points of view is very much a part of the discipline of drawing. Here are only a few of the many possibilities for lessons.

Above and Below

Perhaps the most basic way to find unusual points of view is to imagine them. Exciting drawings can often result from exercises of this kind. We have asked children of various ages to:

> Think of a runner in a marathon. Imagine the runner coming directly toward you. Watch the runner pass and now watch from the back as the runner goes away getting smaller and smaller. Now watch the runner from some surprising angles. Imagine that you are under a glass bridge as the runner passes overhead. What did you see? Now you are sitting on a tree branch that extends out over the track and you watch as the runner passes underneath. Draw the runner as you imagined from above, below and from one other unusual position.

These imaginary bird's-eye-views of a city were produced by students of Dutch art teacher, Maarten Tamsma. One of them shows an interesting section of the city circled off and magnified.

Maarten Tamsma, an art teacher from the Netherlands, has developed some interesting exercises for depicting points of view. In one of his lessons, junior high school students are given aerial photographs of a village on a river. They study the photographs and then draw the village, creating a series of textures in pen and ink so that while they all appear to be different from one another, they still adhere as closely to reality as possible. The students are also encouraged to depict distance. They are instructed to circle one segment of their aerial view and then to enlarge this segment in the same drawing, thus showing a detail and a long-shot within the same drawing. The results are sometimes rich in pattern and texture.

Conclusion

It is no wonder that students wish to depict the illusion of deep space; this way of representing the world is a pervasive part of our graphic culture. If they don't learn some of the basics of perspective, of overlap, of diminution, of planes, of converging lines, then they will think, "I can't draw." The prevailing rules for the depiction of space are easily learned, if they are taught.

Perspective exercises designed to show deep space frequently result in sterile drawings—but not this one by an Advanced Placement student.

Edgar Degas, *Ballet Dancer Standing*.
Baltimore Museum of Art. In this ex-
pressive small drawing, Degas left all of
the original lines of the study. This
repetition gives the viewer both a sense
of immediacy and of movement.

Dynamics: Drawing Action, Duration, Expression, and Emotion

Make your faces so that they do not all have the same expression, as one sees with most painters, but give them different expressions, according to age, complexion, and good or bad character.—Leonardo

In our modern period, the major thrust of art has been toward abstraction and formal structure. Consequently, during the past one hundred years, art teachers have devoted little instruction time to depicting action and movement in humans and animals or to representing bodily and facial expression and emotion.

In mass culture, however, it is quite another story. When formalism and abstraction became the pervasive styles of high art, the literal and narrative aspects of art became the province of the popular arts. Comic books, movies, cartoons, television and illustration assumed the story-telling functions that once belonged to the high arts. Since it is the popular arts that children encounter first and most frequently, it is not surprising that some of them use these popular models to guide their own narrative productions. But, in spite of the fact that the culture "tells" students that they should draw dynamically, only a small number of our students actually master the rudiments of dynamic drawing.

Because we think that instruction in the dynamics of drawing is necessary, here are some of the essentials of a basic program.

Depicting Action and Motion

In the National Assessment of Educational Progress in Art, nine- and thirteen-year old students were asked to: "Draw a person who is running very fast." There are, of course, numerous ways to depict a running figure: to orient the legs and arms diagonally, to bend the limbs at

ALYSSA

These six drawings of horses by eight- to twelve-year old students illustrate a direct approach to skill development. Large drawings of horses after those of a variety of artists (Lautrec, Leonardo, Picasso, Delacroix) were made on a blackboard. After a discussion of the various actions and positions of the horses, the students were given from a few seconds to a few minutes to draw their own versions of the horses in action.

the joints, to give the figure a forward thrust, and to elevate the figure above the ground. By using these or other means, only 21% of 9-year-old students, and more surprisingly only 38% of 13-year-old students could draw a running figure. (Only 3% of nine-year-old and 11% of thirteen-year-old students bent the knees of both legs and depicted the upper part of one leg going forward and the other one going backwards. It is those inborn graphic biases that keep students from bending limbs and orienting legs diagonally.) And yet the ways of depicting simple actions in people and animals can be learned easily by children in the first and second grades—if they are taught.

As part of a second grade social studies unit, children drew the Colonists serving "stone-soup" to British soldiers. A visitor to the classroom watched one little boy as he attempted to show a soldier running. He struggled to depict something that he could envision in his mind but could not draw. Taking a piece of paper, the visitor said, "This is one of the ways that I draw a running figure. I make this leg go out this way, and this one go out behind. I bend the legs just a little bit at the knees; I make one arm stretch out this way, and stretch the other one back. Then I draw the ground-line down below so that the figure appears to be flying." Then the young boy tried it, with great success. Not just one but several running soldiers were soon incorporated into his drawing. And even more interestingly, the other three children at the table who had been watching the little episode also began to depict running figures in their drawings.

What would a program of depicting action in figures and animals look like?

In keeping with the idea that school drawing provides a special art experience—a way of coming to an understanding of the meaning of works of art—skill related tasks should be embedded within assignments to depict themes and topics that are filled with action: sports events, dancers, adventures, etc. There are at least two instructional procedures that might be followed.

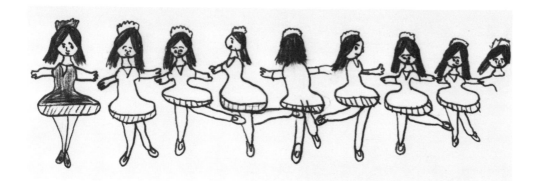

This young girl showed the movement of her ballet dancer through repetition of the figure. In cinematographic style, she appears to whirl about on her toes.

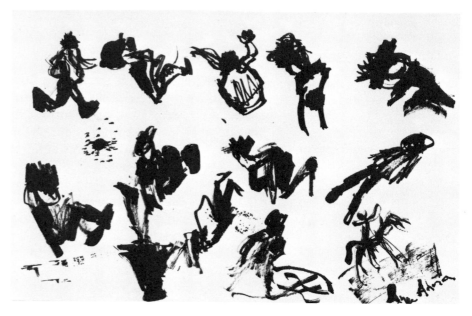

Another way to increase skill in drawing action is to flash images on a screen. These drawings were made from a series of slides taken from the marvelous action-filled images of Wilhelm Busch, the German artist who originated "Max und Moritz," known in America as the "Katzenjammer" kids. To encourage twelve-year-old students to see the relationship between the kinaesthetic act of drawing and the kinetics of bodily action, they were given long pointed sticks and ink with which to draw. The combination of tool and the speed necessary to keep pace with the quickly changing images produced these kinetic images.

One approach is to give specific skill instruction regarding how to depict the action called for by the assignment:

Illustrate on the board how to depict figures in action through orientation and bending of the body and the limbs.

Have students take action poses from which the remainder of the students draw (it is frequently difficult for students to hold dramatic poses for very long, and impossible to pose flying through the air, etc., so we suggest having the models take the dramatic poses of leaping and flying while lying on a blanket or mat placed on the floor).

Flash slides of action-filled drawings of humans and animals on a screen and have students make rapid sketches.

Have students make careful observational drawings from children's toys—animals in action, robots and space heroes with articulated body parts, etc.

The second approach is to assign action-filled themes and topics and allow students to discover the specific action-depicting skills they need to give their figures and animals movement. A struggling student will welcome assistance. Books with the drawings and paintings of artists such as Michelangelo, Leonardo, Rubens, Bruegel, Tiepolo, Goya, Delacroix, Degas, and Lautrec—as well as a stack of comic books—should be available in the classroom. (Be sure to show the relationships between the action drawings of artists and the illustrations of dramatic action in comic books. Spiderman has great moves and lovely foreshortened poses.) Take the books to the students' tables and show them how Tiepolo drew action, or how Lautrec gave his horses elegant motions. Leave books at students' tables so that they can use the artists' works as their models.

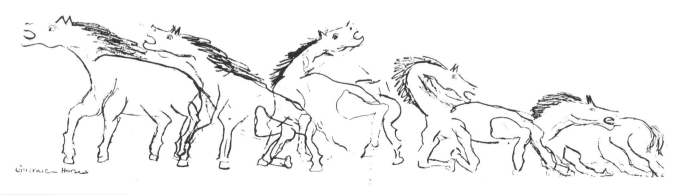

Guernica Horse

Imagine the actions that might precede and follow the actions shown in a drawing. In this assignment students were asked to redraw in the middle of a long sheet of paper a horse from one of Picasso's preliminary sketches for

Guernica. Then they imagined the actions of the horse before and after the action depicted in the Picasso drawing. This drawing shows the horse in the process of struggling to stand. In such an assignment, the further the action

extends from the initial drawing, the more the drawing reverts away from the artist's style to the drawing patterns of the student.

Here is another imagine-the-action assignment. Young children first drew a small folk toy (a wooden horse on wheels) and then imagined the horse in flight. In this drawing the toy appears to have broken before the horse's "bird-astonishing" flight.

To depict satisfactorily a sports event requires skill in placing the human figure in action. These hockey games were drawn by boys from the Soviet Union and United States.

Many Cowboys Jump Blue Ghosts in the Forest.

Words are excellent for initiating action drawings. Here the phrase was "Many cowboys jump blue ghosts in the forest," picked at random from groups of nouns, adjectives, verbs, etc.

Think of all the actions in Bruegel's painting *Children's Games*. This drawing by a child from Finland hasn't nearly so many figures as the Bruegel, but the actions of the children and the setting are both nicely done.

Depicting Expression and Emotion

The ability to depict human emotion adds another small but powerful skill to students' graphic repertoire—a skill that many students fail to acquire.

When students were asked to "Draw an Angry Person" in a National Assessment Exercise, the instructions were:

Sometimes when a person is angry his whole body as well as his face shows how angry he is. In the space on the next page, draw a person who is very angry. Try to make the whole body show that the person is angry.

Three-quarters of the students in the 13- and 17-year-old age groups could not produce a single feature such as knit eyebrows, bared teeth, clenched fists, "angry" kickings and jumpings, etc. Fewer than 3% of either age group could use three of these features together in a single figure.

At one time the depiction of bodily and facial expression and emotion was central to drawing instruction. The art of previous centuries, like our comic books today, was filled with the depiction of human emotion. This ability is still a useful skill. Moreover, its study is a way of understanding the art of such artists as Leonardo, Michelangelo and even Picasso.

In the early part of the 19th century there were basic drawing books with plates showing facial expressions and emotion-laden poses for students to copy. For example in *The Oxford Drawing Book* published

in 1825, N. Whittock wrote "Plate LXVII is a fine head from the passions, by Le Brun, representing bodily pain. In drawing the outline of this three-quarter face, remember the division lines first pointed out, as they will assist you." About another plate (*LXX*) he wrote, "The figure on the burning pile, whose writhing muscles show the acute torture he is suffering is taken from a picture by Guido Rheni."

These drawing books continue a long tradition in Western drawing, extending back at least to Leonardo. In fact, before Leonardo drew, he frequently wrote intricate directions to himself regarding the actions, gestures and expressions of the individuals to be portrayed. As he was preparing sketches for *The Battle of Anghiari* he wrote:

> *You must take the conquered and beaten, pale, their brows raised and knit . . . Make one man shielding his terrified eyes with one hand, the palm towards the enemy while the other rests on the ground to support his half raised body . . . Someone might be shown disarmed and beaten down by the enemy turning upon the foe, with teeth and nails, to take an* inhuman *and bitter revenge . . . You would see some victors issuing from the crowd, rubbing their eyes and cheeks with both hands to clean them of the dirt made by their watering eyes smarting from the dust and smoke.*

We learn from Leonardo's process of drawing expression and emotion that before beginning, it is necessary to imagine the kinds of expressions to be depicted. Leonardo had the expressions fixed in his mind. How do we lead our students to similar vivid imaginings?

The internal graphic plans from which students might draw facial and bodily expressions are probably best derived from a combination of artists' and students' perceptions of expressions.

Few students are able to depict emotion as this student did. The drawing shows the clenched teeth, knitted brows and flared nostrils as well as the radically foreshortened clenched fist of an angry person.

This depiction of a boxing match shows attention to both action and anatomy.

The features of Picasso's grieving woman are mapped onto those of an actual model.

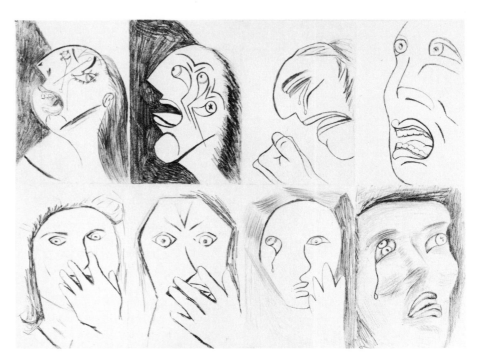

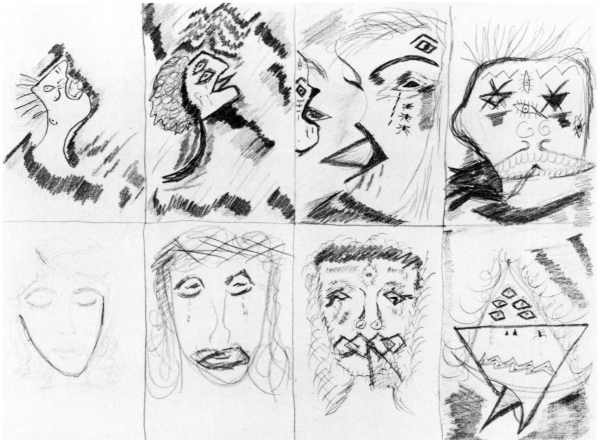

Picasso's Pathos and Other Projects

In his studies for *Guernica* Picasso made repeated sketches of the agonized expressions of both the woman with a dead child and the horse. In a unit of instruction relating to *Guernica,* these sketches were the jumping-off point for a series of drawings relating to facial expression. Students drew from Picasso's depictions of grief-stricken women and then made variations (such as taking the original drawing through a series of transformations, "mapping" Picasso's image onto one of the student's own drawings of a head, and devising other Picasso-like means for depicting grief). The lesson was certainly as much a lesson in criticism through re-creation as it was a lesson in the depiction of emotion.

Think of other works of art that might provide models for the critical study, recreation and creation of drawings that depict emotion: Van Gogh's lithograph *At Eternity's Gate,* Michelangelo's condemned people in the *Last Judgment* in the Sistine Chapel, Chagall's ecstatic floating figures, Munch's *The Cry,* Rodin's sculptures *The Thinker, The Gates of Hell* and *The Burghers of Calais,* and his drawings of dancers such as Isadora Duncan.

Observational drawing, too, can be directed toward the depiction of emotion. Have student models assume poses and facial expressions showing emotion.

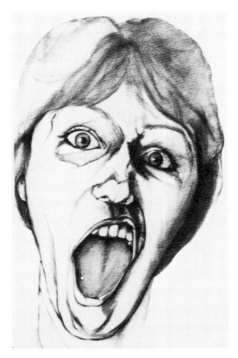

Here a student has drawn her "angry" self-portrait from a mirror image. Since it is difficult to hold such an expression for long, she has distorted the image in the mirror.

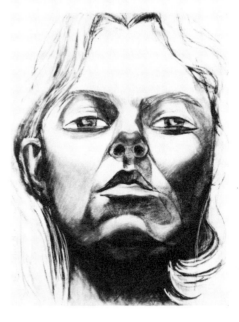

Radical underlighting increases the "sinister" feeling and emotional expression of these two self-portraits.

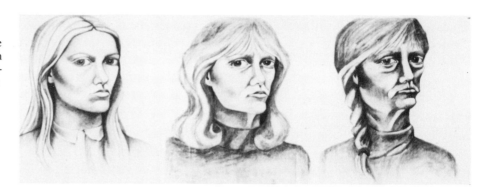

These three drawings show the aging process, imaginatively projected into the future from the initial self-portrait. Such a project might be preceded by a discussion and illustration of the changes that occur during the aging process—the bone structure of the face becoming more prominent, the loosening and wrinkling of the skin, the thinning of hair, etc.

Depicting Duration

Duration has to do with time and its passage. And whether by fact or invention, duration is usually shown through a series of drawings rather than a single drawing. It can be shown through movement in time, such as in the aging process; changes in time, such as growth, development, destruction and cause and effect; or prolonged action, such as a tennis match or a gunfight.

The Process of Aging

Through his self-portraits, Rembrandt has provided a marvelously sensitive record of aging. We have more than ninety self-portraits from age 23 to 63. (In a series of etchings made in 1630 when he was 24, he experimented with various facial expressions by drawing from his mirror-image.) In these portraits it is as if he has stripped away the exterior and superficial layers of personality to reveal the growth of inner character that accompanied his aging.

Growth, Development, Destruction

While aging has occupied some artists, the "journey of life" and other developmental themes have occupied many others. Think of Munch's *Frieze of Life,* Michelangelo's *Last Judgment,* Hermann Hesse's story *The City.* Although it might be an interesting assignment for students to record their own aging process or the development of their environment, few of us would be around to check the final results. Consequently, recording some aspects of duration must necessarily have its imaginative dimension. In depicting duration, students can deal somewhat factually with historical reality and inventively with prophetic reality.

One graphic durational problem might be to draw a self-portrait, and then imagine how you will look over the span of five ten-year intervals. Or try the same task for an often remodeled building, a frequently customized car, a neighborhood (back and forward one hundred years in time), a city, a landscape (perhaps over a thousand-year period), future evolutionary changes in humans, etc.

For a long-term project, take a bite out of an apple and draw it, paying particular attention to the contrasts of surface. Repeat this over the next month or so, drawing the same apple on a weekly basis and noting how time and decay change form.

This drawing in six frames by a Japanese boy illustrates duration in several ways. Time is depicted, first, in the advancement from one frame to the next, and second, as the boy in the drawing is visited with first one "plague" and then another. His attempts to overcome the effects of this deluge lead to his being gradually and progressively overcome, and to his death—another duration: cause and effect.

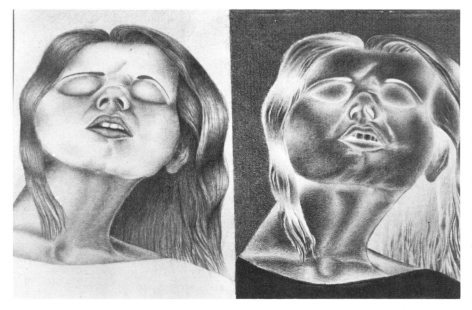

Sometimes duration as well as emotion can be implied merely by altering the "conditions" depicted in two or more drawings of the same subject. In this drawing (made in an art class at the Albright-Knox Art Gallery) a fourteen-year-old girl selected a portion of a work from the exhibition *Figures: Forms and Expressions* and rendered the initial drawing according to the original values. She then rendered a second drawing using opposite values to produce an effect similar to a photographic negative.

Cause and Effect

From the passage of time it is a short jump to cause and effect—the depiction of antecedent and consequence. Rube Goldberg spent much of his life drawing contraptions showing that when "A" happened, "B" resulted, which in turn caused "C" to occur, which . . . and so on. Think of the possibilities. Try creating a Rube Goldberg-type of "machine" to do something that will make your life easier—let the cat out, walk the dog, turn off the alarm clock, transport you to school, etc.

Prolonged Action

One of the most exciting ways in which duration is depicted is in the Japanese comics (or "Manga") that, at an average of 340 pages, are the most widespread reading matter for Japanese men, women, boys and girls. "Manga" was a name, first used by Hokusai in the 19th century to describe his wonderful small woodcuts. The "Manga" of today continue Hokusai's artistic tradition, and use, as well, cinematographic effects. A sword fight, for example, may be continued over the course of three or four pages recording every minute thrust and parry. Not surprisingly, the same kind of duration is found in the narrative drawings of Japanese children. Drawings by American children also reflect the kind of duration found in comics. They show, for instance, increasing fear on a face, panning in—as a camera would—on the beads of perspiration on the character's brow. Many subjects lend themselves to such intensive depiction: battles, races, gymnastics, sports, etc.

The story drawing by a Japanese boy shows time not only in the sequence of events, but also in the cinematographic effects employed—the use of long-shot, close-up, extreme close-up and middle view.

Conclusion

The numerous spontaneous drawings that some students produce are made to tell stories. These graphic narrations put characters into difficult situations where they react emotionally, struggle to overcome, triumph and fail. It is in these drawings, symbolically constructed to test future possibilities, that children spontaneously depict action, emotion and duration. The foregoing exercises can stimulate more young people to use these spontaneous devices in their graphic narratives.

The title on the blueprint for this Rube Goldberg-like contraption is "Easy Company Tea." The caption reads:

Rising bread (a) pushes springed pipe (b) against balancing board (c), forcing heavy bowling ball (d) to roll onto board (e), forcing the spring of basketball (f) to push up on wood handle (g) on oven thermometer (h) causing oven to turn on and bake bread. Handle (g) is helped up by weight (i) which has control of the string. Weight (i) pushes on alarm clock (j) and is set for 50 minutes. After 50 minutes alarm is rung and alarm spring pops knob (k) out of top, pushing weight (i) into air, letting handle (g) swing down to turn off oven (h) and hit button (l) to let oven door (m) open, allowing bread to cool. At the same time the alarm rings, a mouse's tail (n) is freed. The mouse follows his senses to cheese (o) in trap (p). The springs of the trap hit board (q) causing it to spring up and pull with it handle (r) attached to stove burner (s) and turn on burner (t), heating water (u) for tea. The whistle, in turn, will notify baker of warm bread and tea for company.

Pablo Picasso, *Minotauromachy*, etching, 1935, 19 $\frac{1}{2}$″ X 27 $\frac{7}{16}$″. Museum of Modern Art.

From Verbal to Visual: Making Drawings from Words

> *How you should make an imaginary animal look natural . . . Let us say a dragon—take for its head that of a mastiff or hound, with the eyes of a cat, the ears of a porcupine, the nose of a greyhound, the brow of a lion, the temples of an old cock, the neck of a water tortoise.*—Leonardo

Leonardo has provided a verbal recipe for a fantastic visual animal. As contradictory as the idea might sound, it is often words that trigger the visual images which serve as the source of some of the most imaginative drawings.

Those of us of the radio generation realize why this is so. As we sat with our ears glued to the speaker, we "saw" characters, places and actions which now seem richer and more vivid than those that the camera captures on videotape or film. Most importantly, these were our own images—of Jack Armstrong and the heroes of *I Love A Mystery* and *Terry and the Pirates*—rather than those imposed upon us by the visions of others. We often react negatively to television or movie versions of characters and places with which we have formed a personal intimacy through the written word. Indeed, words, spoken or written, can excite the imagination; and what is imagined is food and substance for drawing.

Some of the reasons that verbal stimuli are so useful in the creation of drawings are:

Words have great power to excite and to direct the course of visual imagining.

Words suggest images for which each individual must invent his or her own unique "mind's eye" version.

In the description of even a complex object or event, words focus attention on elements that are essential, rather than on less important elements that sometimes clutter our vision.

Words can be used with great flexibility to create a rapid-fire series of images with startling juxtapositions and improbabilities.

Words can be used at any point in the drawing process. They might first be used to introduce the theme and the basic elements of a drawing, and later to introduce new qualities, subject elements and directions into the drawing as it progresses.

In 1892 Earl Barnes published the results of a sizable study of children's drawings. In describing the methods used to inspire children to draw, Barnes speaks of reading a poem entitled *Johnny Look-in-the-Air*, probably translated from the German *Hanns Gluck-in-die-Luft*. In 1909 Lou Eleanor Colby devoted two pages in her book to the poem and two more to children's sequential illustrations. Colby felt that the poem was well suited for illustrative purposes in the schoolroom because "it deals with familiar objects, and is full of dramatic action and incident."

We present part of the poem here, accompanied by pre-1909 second grade children's illustrations of the poem and by their contemporary counterparts, also by second graders.

Johnny Look-In-The-Air, the 1980's version complete with cartoon balloons. Although the versions drawn seventy years apart are stylistically different, they still focus upon the essential portions of the poem.

Johnny Look-in-the-Air

As he trudged along to school,
It was always Johnny's rule
To be looking at the sky
And the clouds that floated by;
But what just before him lay
In his way,
Johnny never thought about;
So that everyone cried out,—
"Look at little Johnny there!
Little Johnny Look-in-the-air."

Once with head as high as ever,
Johnny walked beside the river,
Johnny watched the swallows trying
Which was cleverest at flying.
Oh! What fun!

Johnny watched the bright round sun,
Going in and coming out,
This was what he thought about,
So he strode on, only think!
To the river's very brink,
Where the bank was high and steep,
And the water very deep;
And three fishes in a row,
Stared to see him coming so.

One step more! Oh! sad to tell!
Headlong in poor Johnny fell.
The three little fishes in dismay
Waggled their heads and swam away. . . .

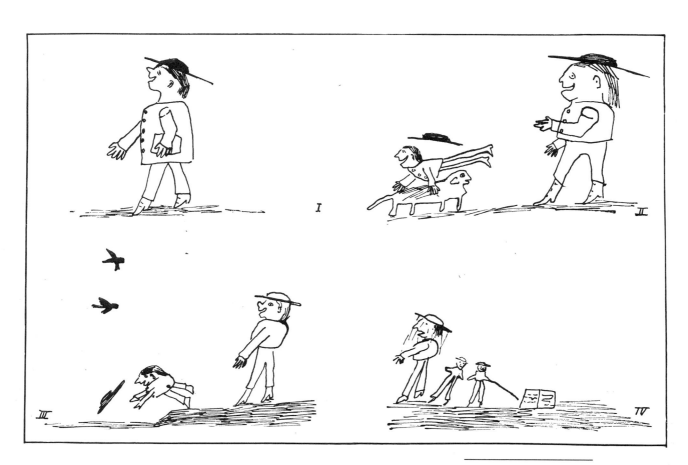

Johnny Look-In-The-Air, the version
drawn prior to 1909.

This poem serves as a satisfying stimulus for drawing for several reasons. It has a definite story line, vivid action and effect sequences, and elements of tension that encourage the children to anticipate visually what will happen next. The poem also encourages the child to draw characters, actions and settings that they may not have visualized or attempted before. Although *Johnny* points the way to drawing from images created by a verbal stimulus, it only scratches the surface. Just a few of the possibilities are:

Drawings from stories, myths, folktales, rhymes, limericks and song lyrics.

Drawings from verbal fantasy games and from descriptions of events, persons, places and things—imaginary or otherwise.

Drawings from descriptions of paintings, drawings, prints, sculptures, etc..

Drawings from Stories, Myths, Folktales, Rhymes, Limericks and Song Lyrics

The secret to eliciting imaginative drawings using a verbal stimulus is to start with things that are themselves exciting, and there is hardly a more exciting place to begin than with the limericks of Edward Lear. Consider the possibilities of this rhyme:

There was a Young Lady whose bonnet,
Came untied when the birds sat upon it;
But she said, "I don't care! all the birds in the air
Are welcome to sit on my bonnet!"

Some questions that might be asked following the reading of the limerick are as simple as: What is a bonnet? Could it be really big? How many birds could sit on a huge bonnet? What kinds of birds? Can you name some of the types? Edward Lear's own illustrations may serve the teacher as a good starting point for more illustrative questions: Are there birds flying in the air around the hat? How does the lady feel about having all the birds sitting on her hat?

In a single class period, students may draw from a whole series of limericks.

Drawings from Other Literary Sources

A comprehensive anthology of literature for young people is a great resource for a classroom. Such books often contain everything from Mother Goose rhymes, through poems, fairy tales, fables, myths, legends and hero tales, to stories of actual people. Like the poem *Johnny Look-in-the-Air*, most of these works have a strong narrative. Discussions of how the important elements in the narrative sequence might be depicted may follow the reading of one of these works. Vivid and dramatic discourse contributes still another dimension to the potentially exciting, verbally-initiated drawings. And the students will be working in the long and rich tradition of literature-to-art practiced by

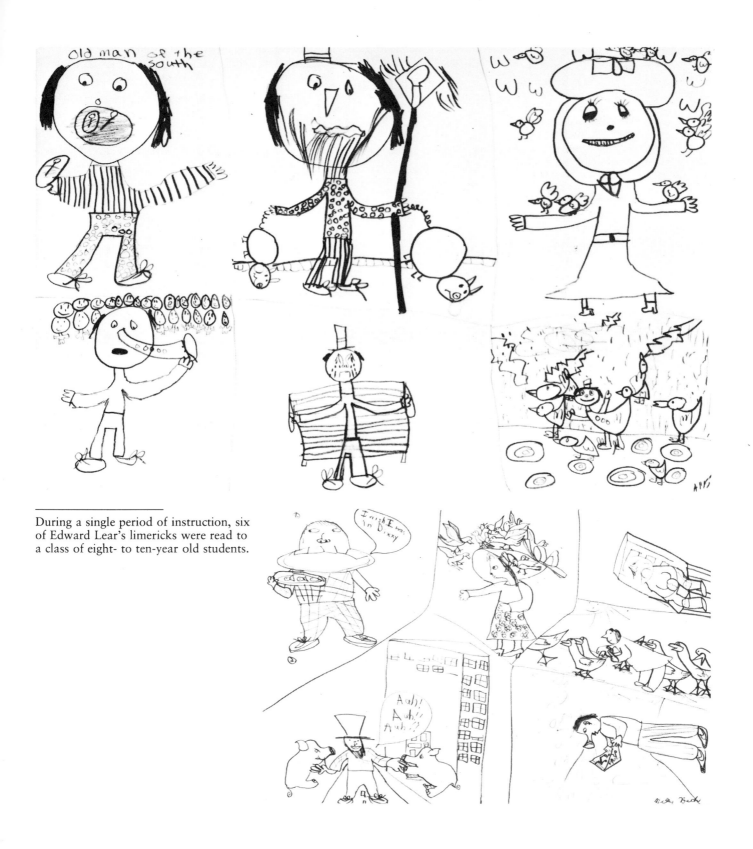

During a single period of instruction, six of Edward Lear's limericks were read to a class of eight- to ten-year old students.

Illustrators are sources for studying drawings that are often neglected. In working from John Tenniel's famous illustration for Lewis Carroll's *Alice in Wonderland*, the teacher read the poem, gave each student a xerox copy to study and asked him/her to illustrate the confrontation scene between the two main characters. When students completed their drawings, they were shown Tenniel's treatment of the same scene, paying attention to his interest in detail, the positioning of the characters and the artist's use of exaggeration. In the second phase, students reorganized their own and Tenniel's vision. They "tamed" the monster by placing him in a domestic situation. The following lines are the key to the Jabberwock's appearance:

"Beware the Jabberwock, my son!
 The jaws that bite, the claws that
 catch!
Beware the Jubjub bird, and shun
 The frumious Bandersnatch!"

And, as in uffish thought he stood,
 The Jabberwock, with eyes of flame,
Came whiffling through the tulgey
 wood,
 And burbled as it came!

such famous artists as Giotto, Michelangelo, Rembrandt, Blake, Hockney and Rauschenberg, or the great children's illustrators such as N. C. Wyeth, Maxfield Parrish, Tenniel and Maurice Sendak.

Drawings from Verbal Fantasy Games and other Descriptions

Marion Richardson, who spent much of her life teaching near Birmingham, England, was surely one of this century's outstanding art teachers. Frustrated because she could not provide her students with suitable visual examples from which to work, she devised a method of supplying her students with "word pictures." She could describe settings and events in such vivid detail that students were able to create works of amazing correspondence to the work described. She described her discovery of this method:

But I had no lantern [slide projector] in the studio at Dudley, and my means of providing large and suitable illustrations was very limited indeed. One day I decided to try to give the children a word picture. I asked them to shut their eyes while they listened to the description of a little local street, lit by the moon, as I had myself seen and painted it a short while before. I was surprised and delighted with the results. No doubt the fact that I had seen the subject as a picture gave colour and point to my words and reduced them to what was artistically significant.

The oldest stories are among the best sources for drawings. As a part of an ongoing cross-cultural research project, students from countries as diverse as Korea and Qatar have been asked to draw from the Biblical account of Noah's ark and the flood. Children from different cultures frequently choose to depict quite different aspects of the story. A Maori child from New Zealand pictured the ark as an elaborately decorated tribal structure and incorporated traditional designs into the sky and water elements. An Aboriginal Australian child depicted several episodes of the story in a single frame: we can see the lightning, the rain beginning to fall, people climbing a mountain to escape the deluge, and the ark floating between the mountains.

Later "word pictures" included her descriptions of the interior of a London theater, the audience, the curtains, the stage, spotlight and performers. The paintings and drawings resulting from her descriptions almost look as though the students had worked from a whole series of sharply focused photographs. Hardly. The sharply focused photographs were merely mental projections, stimulated by Marion Richardson's vivid and detailed words.

Composing Verbal Images

When students work from literary sources they are not only exposed to well formulated narrative sequences but also, in many cases, to beautiful descriptions. And yet these "borrowed" verbal sources have at least one major shortcoming. Someone else's words may fall short of a teacher's own goals to elicit the elements, themes and concepts that he or she might wish students to practice in their drawings. One solution is to create original verbal descriptions tailored to fit the needs of students, much as Marion Richardson did. The following descriptions are examples of the kinds of verbal stimuli that teachers themselves might create.

The Gigantic Bicycle Crash

This description was designed to encourage students to produce complex drawings showing cause and effect, overlap, figures in action, bicycle parts that have been distorted and the overall expressive quality of a crash.

The area had as many kids on bicycles as you would find ants on an anthill. For a reason no one has been quite able to explain, all the bikes suddenly headed for the same spot. There were all those bicycles crashing into one another and kids and bikes flying through the air. No one was hurt seriously, but what spills they all took, with arms, legs, heads, bodies, bicycle wheels, handlebars and frames falling into one gigantic tangle. Can you see it in your mind's eye? Draw a picture of the giant bicycle accident with things flying about and the biggest tangle of bicycles and boys and girls that you possibly can.

These three drawings of "The Gigantic Bicycle Crash" by third-grade students illustrate how an intriguing verbal description can elicit dynamic drawings which include action in human figures, overlap of objects and unusual compositions.

Otherworldly Parades

It can be just as much fun for the teacher to create the description as for students to draw from one such as this (which unabashedly acknowledges its debt to Edward Lear's *Fimble Fowl with a corkscrew leg, The Pobble who has no toes,* and *The Dong with a luminous nose*).

Row upon row upon row, as far as the eye could see, marched all the strange creatures of Tamarinanon—the two-headed Pompador with the crickledy necks, and the curious speared and armored Folderol, the great tall one-eyed Cavendish and the three-toed Tootle. Above them flew the Pom-and-Timmins, not quite bird nor quite insect, with sharp beaks and pointed heads, their gigantic wings flapping in the air. And below them all, creeping along on balloon-like bellies, were the Quangaloons without a nose, this great long procession of creatures, this never-ending parade.

Verbally inventive descriptions such as this exercise the imagination and lead easily and enjoyably to graphic inventions. The images above also encourage students to use overlap and diminution in their drawings.

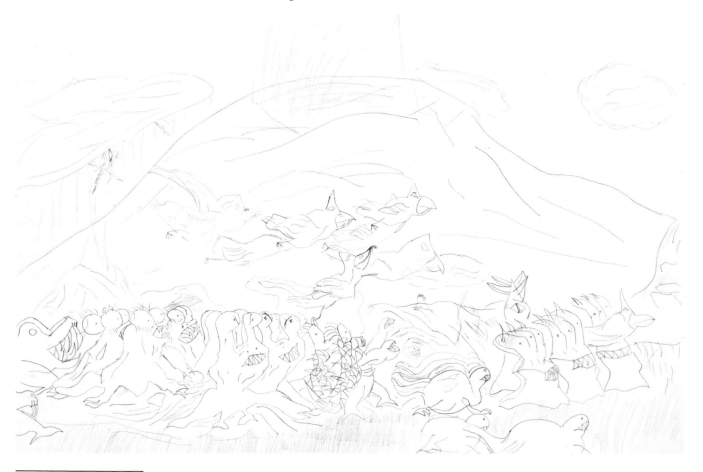

The imaginative characters in this otherworldly parade were evoked by their Edward "Learish" names. The teacher encouraged this fifth-grade student to overlap the figures as a way of getting more creatures into the grand procession.

One of the most enjoyable ways of expanding the types of images that students are able to draw is to give verbal descriptions from which the students draw. The characters in these parades drawn by five-year-old boys result from the teacher's describing, one at a time, the features of imaginary characters. If children finished before the teacher's next description, they were encouraged to draw their own characters. Before long the children themselves were not only providing verbal elaborations to the teacher's characters, they were also taking the lead in describing "funny" people for everyone else to draw.

Getting Students into the Descriptive Act

Verbal descriptions are successful with intermediate grade students and beyond. Variations of these verbal initiators of drawings can be used with very young students. (And these variations may, in turn, also be used with older students of any age.) The variation may involve the verbal fabrication of a setting or context followed by the description of single elements, one at a time, until the whole drawing has been completed. One of the most exciting possibilities of working in this manner is that the students may, and often do, make up their own verbal as well as graphic fabrications of the characters and objects.

A group of 4-, 5-, and 6-year-olds were told that they were on another planet, marching at the head of an enormously long parade. After drawing themselves at the head, they were provided with full descriptions of characters such as one with a fat belly "out to here" and a nose like a bird; another with flowers growing from his head; a woman with very long hair. In no time at all the group joined in with their own contributions—a man with an elephant head, a turtle with

two heads, and a fish with legs. And when they had completed the drawing of the described characters, they added their own non-verbally derived participants to the grand space parade.

Some of the verbal descriptions to which students contribute acquire a decidedly story-like character. For example, students were asked first to visualize and then to draw two tall trees, one on the left edge of the paper, the other on the right. Between the trees they were to have an elephant appear, then a monster to threaten the elephant, etc. Before the game was over, thanks to the students' contributions, birds had come to the trees; they laid eggs in nests; the eggs fell, broke, and little elephants and monsters emerged from the broken eggs; the little ones searched for their mother monster (or mother elephant), and so on.

Descriptions and Drawings of the Insides of Things

In his book, *Put Your Mother on the Ceiling,* Richard de Mille presents a marvelous technique for visual fantasizing. Although de Mille did not intend that his descriptions be the source of drawings, his methods are wonderfully adaptable. Here we present a de Mille-like game, containing quite un-de Mille-like subject matter—city plumbing, (inspired by a description of a city in Italo Calvino's book, *Invisible Cities).*

The teacher began by asking five-year-old students to visualize and draw first trees and then an elephant. The students then took over both the storytelling and drawing roles. The elephants were threatened by monsters; eggs dropped which hatched both little monsters and elephants who then had to find their respective mothers. The communal creation and drawing from the images in stories can take some very surprising turns, indeed.

Imagine a large city far in the distance.
Move the city closer.
Notice the skyscrapers, governmental buildings, apartment houses, warehouses, factories.
Remove the walls, floors, ceilings, roofs from every building in the city. Now all you see is miles of pipes—the plumbing—spreading horizontally where the floors should be, and vertically upward where skyscrapers used to stand. Single enormous drainpipes, clusters of delicate waterpipes criss-crossing, branching and paralleling one another.
See the "forest of pipes that end in taps, showers, spouts, overflows."
Silhouetted against the sky observe the white sinks and bathtubs hanging like ripened fruit from branches.
If you look carefully you may even see inhabitants balancing on pipes while brushing their teeth at sinks, and showering under water spouts.

This verbal drawing initiator was written at a level that might be presented to older students. By changing a few words it could be presented to much younger students. Exercises such as this are not only useful for stimulating visual imagination but also serve as opportunities for tackling graphic problems such as overlapping—as of one pipe with another.

A humorous randomness can enter into the verbal-to-visual game. Students picked a series of words from four boxes containing nouns, adjectives, adverbs and verbs, and arranged the words into a phrase. Phrases like "Four ugly bugs walk seals near the beach" and "Three horses jump purple giants together in outer space" can motivate exciting drawings.

Think of the possibilities for drawing projects based on verbal descriptions of the insides of a factory, the human body, an engine, a castle, a mysterious forest, Purgatory, etc.

Drawings from Descriptions of Artworks

Descriptions of works of art of all kinds provide rich verbal stimuli for drawings. Describing a work of art in careful enough detail to enable someone to work from it demands an extremely sensitive perception of the work.

Have students describe works of art as if for someone who is blindfolded. They must make that person see in their mind's eye every single thing in the work—where everything is placed, the actions, the shadows and shading, the expressions on faces, whether things are sharp or fuzzy, etc. In this way, the student describing the work will benefit from an often unexpectedly intimate view of the work.

Getting Lost in the *Persistence of Memory*

The following description of Dali's *The Persistence of Memory* may produce some interesting works from high school students. (Note that in these descriptions the drawings need not look at all like the works of art that inspired the descriptions, and that getting lost in a description provides some interesting visual problems to solve in one way or another.)

> You are walking inside a wide desert of a picture when off in the distance, taking up one-third of your vision of that vast landscape, the light of the sky, ranging from darker tones down to an almost eerie brilliance on the horizon, illuminates a cliff-like protuberance that appears to loom, or to float as though on water, or to find its reflection in the sky or in the desert itself. This edifice juts out of the right side of the frame of your vision and insinuates itself almost, but not quite, halfway across the horizon line. Adding to the feeling of ambivalence about the existence of this floating island, a small sphere, like a pearl, rests below it and just above the horizon, casting a long horizontal shadow in its reflection.

This is only a beginning or mood-setting excerpt from a description that grew to be even more complex than the painting itself; and in the case of the "Persistence of Memory" the description could easily do so. The problem is in the students' ability to retain verbal descriptions long enough to draw from them. One solution is to have a copy of the description printed for each student. One student's description may even be written down and copied for other students. It is important for students to achieve greater complexity, imaginativeness and aesthetic qualities in their work; it doesn't really matter a lot whether the resultant drawing resembles the work of art originally described. When the students have completed their drawings, show them the work and have them discuss Dali's work in relation to their own.

One description of Picasso's *Minotauromachy* resulted in twenty quite different drawings of which these are only two. The secret to success in "dictating a drawing" is always to indicate the placement of objects, their relative size, the direction they are facing, as well as a detailed description of their characteristics and qualities. But even with highly detailed and accurate descriptions, each student hears and imagines his or her own unique version. Moreover, the dictation and drawing create the tension of a good narrative. The students anxiously wait to hear what comes next, and the greatest excitement comes when they finally get to see the drawing that has been described. In the case of *Minotauromachy* students had difficulty believing that a single print could have all those features.

Here are some suggestions for works of art to describe. If you do not have posters or slides available of these works, they may be found in Gerald Brommer's *Discovering Art History* (1981) or in H.W. Janson's *History of Art* (1977).

The Laocoon Group

Portrait of a Roman

The Defeated Persians under Darius

The Battle of Hastings, (detail from the *Bayeux Tapestry*)

Martin Schongauer's *The Temptation of Saint Anthony*

Niccolo Dell'Arca's *The Lamentation* (detail)

Pieter Bruegel's *The Blind Leading the Blind*

Franz Hals' *Malle Babbe*

Georges De La Tour's *Joseph the Carpenter*

John Henry Fuseli's *The Nightmare*

Caspar David Friedrich's *The Wreck of the 'Hope'*

George Caleb Bingham's *Fur Traders on the Missouri*

Vincent Van Gogh's *Wheat Field and Cypress Trees*

Francisco Goya's *Bobabilicon*

Honore Daumier's *The Third-Class Carriage*

Conclusion

The leaders of the child art movement—Franz Cizek and Viktor Lowenfeld—recognized the power of verbal descriptions to stimulate imaginative pictures. Unfortunately, their methods have been used primarily with younger children. Drawing from words should be a central part of drawing programs for students of all ages.

Almost any work of art may be considered a source for description, which in turn is a source for drawing. Works that are extremely complex will probably be best described generally, with emphasis placed on the overall subject and the pervasive expressive quality of the work. Simple works sometimes call out to be described in great detail.

Larry Rivers. *The Last Civil War Vet-
eran*, 1961. Pencil, black crayon and
paper collage with white gouache, $9\frac{15}{16}''$
X 8″. The Baltimore Museum of Art.

"The Art In It": Talking and Writing About Drawing

The first man who began to speak, whoever he was, must have intended it. For surely it is talking that has put "Art" into painting . . . It is very interesting to notice that a lot of people who want to take talking out of painting, for instance, do nothing else but talk about it. That is no contradiction, however. The art in it is the forever mute part you can talk about forever.—Willem De Kooning

Drawing (or redrawing) is an important means to interpret works of art. "Drawing upon drawing" (art based on art) is one way that the essential qualities and messages of art from the past are renewed and revitalized. Drawing is a conscious act, and when students "draw upon drawing," they direct their attention not only to their own graphic abilities but also to the graphic abilities of the artists. In this way, students look at how the artists have dealt with theme, style, expressive quality, subject matter, composition, media and technique.

When students interpret a work of art through redrawing, they are on their own. They are the mediators in a private dialogue between an accomplished work of art and a work of art-to-be. The act is one of solitude.

But drawing from works of art is not the only means of gaining insights into the problems of the artist. There is much to be said for having students set aside their pencils and brushes in order to see what makes a master drawing "tick."

In a communal discussion of art, the marks and tones of drawings are translated into words and phrases for all to hear, to approve or disapprove, to supplement, to elaborate. Indeed, the communal study of a work of art can be compared to a see-saw, with careful teacher-directed analytical approaches resting at one end and intuitive, spontaneous student reactions at the other.

The entire range of features, qualities and characteristics of a work of

art are fair game in these sessions. The discussion might start almost anywhere and go anywhere. Consider factors relating to media. Children in the primary grades may not need to know the meaning of "bistre", but they are capable of pointing to the difference between pastel and oil crayons, between charcoal, soft and hard pencils, felt pen, metal nibs, bristles and soft brushes. Children can be led to identify the qualities and consequences of drawing media. To them it can become a game whose rules can transfer easily into other concerns. For example: How would the meaning of the drawings of Ingres and Kollwitz change if they exchanged media? Treated in such a context, media is revealed as a key link between the meaning of the drawing and the style of the artist. When students become aware that materials have such importance, they will begin to take these tools of the artist into account when studying, discussing, or writing about drawings, as well as when making them.

From the study of the qualities of the media of drawing, it is an easy step to move to the employment of media, to the techniques and processes of drawing. These statements about technique are the kind that teachers might make about drawings, and that, before long, students can begin to make about the drawings of artists:

That drawing shows that pencil can be smudged, but crayon can't.

Look at how pastel and chalk can be sprayed with fixative and other layers added. Compared with pen or pencil, pastel is soft, less-linear, more color-centered.

These lines made with a hard pen are regular, placed in parallel patterns and cross-hatched; these lines from a soft pen are more variable in thickness and variety.

See how soft pencils respond to pressure, and although they can be smudged they can never give the same qualitative response to pressure that a watercolor brush can.

This drawing shows how charcoal lends itself to tonal gradation. But look at how charcoal involves more than working with a stick. The use of a "stump" or rolled paper, or a chamois cloth gives charcoal drawings subtle tones. As you can see here, charcoal loves the subtractive power of an eraser. Charcoal is versatile; although it was the pet of the academies, Van Gogh chose it to tell a story of the harsh existence of a peasant as he drew his shoes. (A question that might be asked in this context is: What did Van Gogh accomplish with charcoal that was denied a master of the High Renaissance who used silver point in a drawing of the Madonna?)

Talk about media and technique introduces the realm of style. Rather than isolated concerns, the three factors of media, technique and style should be viewed as all adding to the meaning, intent and feeling of the drawing.

Studying Larry Rivers' *The Last Civil War Veteran*

The following incorporates a number of the factors discussed above:

Studying a work such as a drawing by Larry Rivers can be useful in moving young people away from a strong bias towards realism and inspiring more imaginative and perhaps selective ways of thinking about and making art. Students at all levels find both the style and the subjects in Larry Rivers' work interesting. They are also quick to recognize and respect his ability to draw in a traditional manner.

The Last Civil War Veteran is one of many preliminary drawings made by the artist prior to the final painting. It illustrates many of the characteristic elements of his work: the way he has chosen to delete, develop, erase, add, suggest, and, in so doing, to move the viewer's eye from one section of the picture to another. Rivers lays it all out for us. He reveals his way of working so that we can almost think along with him as he goes about creating a totally new treatment of an event—in this case, an imaginary funeral of a symbolic figure in American history.

To talk about drawings and other works of art, students must develop an effective vocabulary to express their ideas about themes, styles, expressive character, compositional aspects, sensory qualities, techniques and processes, and finally meanings. Some of these words are factual; some are adjectives; and some deal with broader artistic and aesthetic concepts. The more differentiated our vocabulary, the more we can begin to see and to understand.

These activities are best done while looking at a slide of the work. (It might also be useful for each student to have a xeroxed copy of the drawing.) And it is important to ask questions that cannot be answered without direct reference to the drawing. Some of the key elements in Larry Rivers' drawing are the kinds of linear qualities. In directing the students' attention to these elements, teachers can ask: Are the lines gestural, contour, searching, spontaneous, deliberate, hard, delicate, suggestive? What are the effects of these line qualities on the expressive qualities and meaning of the work?

Other aspects of the drawing involve tones, smudges, marks, erasures, ambiguous forms, negative spaces. Although the questions require the matching of drawing vocabulary with evidence found in the drawing, don't expect that all students initially will see the same features. In fact, the discussion can be a good deal livelier if different points of view are expressed. The teacher may ask, "What kinds of pencils did Rivers use, hard or soft?" The answer could be either or both. It is also reasonable for someone to assume that the artist used soft lead, but lightened the pressure in order to create the more delicate vertical and horizontal lines. The point is that questions should be asked that cannot be answered unless the students are carefully studying the drawing. Students should also be able to point to such pencil techniques as:

Tones that have been created by lines.

Gradation of tone, from darkest to lightest.

Lines that have been mechanically drawn.

"Planning" lines that shape another form.

Lines that suggest—but do not complete—a form.

Areas or lines that are "smudged."

The last section concerns questions of medium, style, method and technique. Other questions to explore relate to structure or composition such as: "How does the artist achieve a feeling of balance or imbalance?" (Empty space against drawn forms; loose, gestural lines against more form-defining lines, etc.) Still other questions deal with subject, theme, expressive quality and meaning aspects of the work.

Building an Awareness of Drawing Techniques and Processes

The following drawings by European and American artists have been selected for the possibilities they offer in developing a drawing vocabulary. (Reproductions of drawings such as these might be made available to each student or small classes might work with a single set.)

The qualities in drawings that result from the use of particular media, techniques and processes are usually easier to see in original works. But many of these qualities are sufficiently evident in reproductions to enable students to develop a vocabulary of terms. For example, these questions might be asked about the drawings:

Which drawing is the most *linear?* Students might identify the drawings by Dubuffet, Kelly, Kley, Klee and perhaps even Mondrian or Sheeler. It doesn't matter; the discussion that might follow as students defend their choices could be the point at which both their perceptions and conceptions are sharpened.

Which drawing is the most *tonal?* The drawings of Seurat, Ruscha and Dickenson are perhaps the prime candidates. If students select the Dubuffet or Mondrian drawings, are they wrong?

Which drawing has the greatest *spontaneity of line;* which drawing is the most *improvised?* Klee's drawing is an obvious choice. But what if some students choose the Kley drawing?

Which drawing combines both aspects of *gesture* drawing and *parallel hatching?* Kley's drawing seems to be the only one that fits these two classifications.

Is there more than one drawing that has been made using the *contour* drawing process? The Kelly drawing is the obvious choice. If students select the Kley or the Klee drawings, are they wrong?

Edwin Dickinson. *Portrait of a Woman*, 1937. Pencil, 9$\frac{15}{16}$″ X 12$\frac{15}{16}$″. The Baltimore Museum of Art.

Elsworth Kelly. *Sweet Pea*, 1960. Graphite on white wove paper, 22$\frac{1}{2}$″ X 28$\frac{1}{2}$″. The Baltimore Museum of Art.

Paul Klee. *Geringer Ausserordentlicher, Bildnis*, 1927. Brush and dark blue wash on off-white laid paper, 18$\frac{1}{8}$″ X 12″. The Baltimore Museum of Art.

Charles Sheeler. *Rocks at Steichen's,*
1937. Conte crayon on off-white wove
paper, 16″ X 13¾″. The Baltimore Mu-
seum of Art.

Heinrich Kley. Untitled, ca. 1899.

In which drawing do you find the greatest amount of *smudging and
erasing?* The Mondrian drawing seems the most likely choice. If
Mondrian smudged and erased more than Dickinson, then does that
mean that he is not as good an artist? What are the consequences of
Mondrian's smudging and erasing? What do these techniques con-
tribute to the expressive quality of the drawing? How do they effect
its meaning?

Probing the Character of Drawings

Too often, it seems that students' responses to drawings involve a
superficial search for a variety of lines, shapes and textures. Such an
activity might be likened to the attempt to probe deeply into the charac-
ter of an individual and to arrive at insights such as, "He has skin, hair,
muscles, a head, eyes . . ." The mere identification of physical features
of either humans or drawings tells little of their unique character. Stu-
dents need to be encouraged to search for the pervasive and the expres-
sive qualities, the "flavorsome" features that set one drawing apart, at
least in some ways, from all other drawings. They need to learn to ask a

drawing, "How are you different from all other drawings?" and "What are the significances, the consequences, the meanings of your differences?"

Becoming a Seurat Drawing

One way to get students to attend to the character of drawings is to tell them, "You are the drawing *Two Men Walking in a Field* by Seurat. Tell what you are like. What are your most distinguishing features? How do those features affect everything about you? How do those features determine your meaning?"

And here are some of the things that students—speaking as if they were the drawing—might say:

> Atmosphere is my distinguishing feature. Within me, two figures, one near and one far, are enveloped in a sea of atmosphere. They are in my softness; my softness calms them, makes them move slowly and silently. My softness even quiets the tension between the two figures. My atmosphere results from conté crayon on textured paper; the crayon and the paper tell my atmosphere that it will be at once linear and non-linear. I am stripped of all unnecessary detail; I am stark and yet I am not cold. I grasp you in my calmness.

Georges Seurat. *Two Men Walking in a Field*, ca. 1882–1884. Conte crayon on laid paper, 12½″ X 9½″. The Baltimore Museum of Art.

Becoming Ruscha's *Soup*

What might Ruscha's *Soup* say about itself?

> *My*
> *Noodle*
> *Noodle*
> *Noodle*
> *Noodle*
> *Makes my soup*
>
> *My artist played with gunpowder*
> *and made shiny noodle ribbons*
> *trompe l'oeuil*
> *to fool the eye*
> *to make eyes play*
> *around my curves*
>
> *My soup twists elegantly for the sheer joy of floating*
> *in a potential explosion*

In this case, in "explaining" itself, the drawing became poetic. And to think in poetic terms is to make associations. These associations (metaphors, analogies, similes) are important ways of characterizing drawings. And students need not be poets to play the role of poets, to respond to drawings as poets might.

Ed Ruscha, *Soup*, 1970. Gunpowder, 13″ X 21⅞″. The Baltimore Museum of Art.

Piet Mondrian. *Trees at the Edge of a River*, ca. 1908. Charcoal and estompe on buff laid paper, $28\frac{5}{16}''$ X $33\frac{1}{2}''$. The Baltimore Museum of Art.

Listening to Mondrian's *Trees*

And if Mondrian's drawing *Trees at the Edge of a River* could speak, what might it tell us?

> I exist in two parts, one self above the river and another self reflected on the surface of the river. My upper self is more the way you might see me in the world. My lower self is the way my master's art is becoming. On the water, the spaces between the reflected trunks and branches of my trees are becoming more important than the trunks and branches themselves. These spaces are becoming parts of a grid—rectangles and squares reflected in the river. Those rectangles and squares bordered now by branches will become in future paintings black lines as steady and strong as the steel girders of a skyscraper under construction. Now I reflect nature, but not for long.

Jean Dubuffet. *Untitled,* 1960. Pen and
India ink on heavy white wove paper,
9⅝″ X 12⅞″. The Baltimore Museum of
Art.

**Speaking Non-Objectively about
an Untitled Dubuffet**

Obviously this drawing's "speaking" about itself has been informed
by a knowledge of what was about to happen in Mondrian's art. But if
one who "speaks" for a painting knows of its place in the scheme of
things, then should that not enter into the characterization?

Non-objective works of art are among the most difficult to "hear" as
they "call out" to be experienced in appropriate and particular ways.
They have none of the literal features associated with our everyday
perceptions. They have none of the actions and emotions of the partici-
pants in our objective world. But is it incorrect to associate a non-
objective drawing with the things that we know? Let's listen to what
Dubuffet's untitled drawing might tell us:

I have no one interest upon which to center. All my centers are interesting. But you will have to look carefully and do your part in creating the interest. And when you look carefully at me, you will see that I am full of variations, like weathered paint on the sides of old boards. My patterns are those of maps of mammoth cities in worlds you do not know. My lines are of cells seen under a microscope. You can get lost in my mazes, cluster where I cluster, open up in the little resting spaces. But to do these things you will have to get lost in me.

Indeed, having students say something or, better still, write something about a work that at first stimulates little interest is one of the best ways to discover the benefit of getting lost in almost any good drawing, whether objective or non-objective.

What Do You Have That I Don't Have?: Single Words That Characterize the Expressive Qualities of Drawings

It is a useful exercise to ask students to make a list of adjectives that characterize one drawing, and another list to characerize a second drawing. The task becomes even more interesting when the subject matter of the drawings is essentially the same, but when the style, media and technique are different.

These words might characterize Paul Klee's drawing of a figure: witty, whimsical, playful, lilting, zig-zagging, flexible, multifaceted, active.

These words might be used for the *Portrait of Mrs. B* by Dickenson: pensive, calm, brooding, sedate, silky, subtle, shaded.

When drawings have some similarities such as the lines in the drawings of Kelly and Kley, or of Mondrian and Sheeler, the task of constructing lists of distinctive adjectives becomes even more interesting. See what your students do with these two tasks.

Conclusion

Most students have the habit of "speed reading" drawings. And most drawings merit much more than the three or four seconds that they get from the casual viewer in a gallery or the peruser of a book of drawings. The redrawing from drawings is one way to make looking vastly more intricate and insightful, and talking and writing about drawings is another important way. Both of these activities may have reciprocal consequences; the student who can characterize in words the qualities of a fine drawing might also be able to achieve similar qualities in his or her own drawing. The student who can draw those qualities might also have some insightful things to say about them. But the connections are not automatic. In the drawing program both activities need continual encouragement and "cross-pollenization." Both are important means by which the meaning of drawings is developed.

Some teachers arrange their art rooms
with subjects for thousands of drawings.

Chapter Fifteen

Questions Most Asked About the Teaching of Drawing

The following are some of the most frequent questions about teaching drawing that the authors have been asked during drawing workshops for teachers. In our answers, we reemphasize some of the aspects of our approach to teaching drawing.

Q: With all your emphasis on teaching drawing through works of art and attempting to influence students, isn't your goal actually the elimination of child art?

Yes and no. We would like to teach children in such a way that when they become adults they do not continue to draw like children (unless they deliberately choose to work in the style of children as Klee and Dubuffet did). Yet we hope that children's spontaneous drawings will remain child-like for as long as the children wish them to be. Remember that even when children work with the themes, ideas and expressive qualities of works by artists, they still interpret and re-create in their own ways.

We love child art just as much as the great proponents of child art such as Lowenfeld and Cizek did, although we are certainly more realistic about it. Attempts to preserve child art at all costs (as did William Viola, a follower of Cizek) actually does a great disservice to the child. Children don't remain children for very long, and we not only need to provide them with knowledge about drawing and an opportunity to learn drawing skills, but also, through a re-creation in drawing, we need to convey to them the messages of important works of art.

Q: But when you teach from the ideas found in the works of adult artists, aren't you ignoring the unique world of the child?

Many art teachers, especially those who follow the ideas of the creative expression and child-art movements, have stressed the everyday personal world as the primary subject matter for students' art. However, those same children whose teachers encourage them to draw

themselves walking to school, playing on the playground and brushing their teeth, will spontaneously make drawings of romance, encounters with monsters, crime and worlds at war. The world of the child is not only the present everyday world; it is also a world of the imagined future, visions of which may be found in adult art and the mass media. The "world of the child" is a romantic notion imposed upon children by well-meaning adults. Children spend much of their play time and spontaneous drawing time imagining what it is like to be grown up. It is a world we can help them to encounter through the study and re-creation of the themes and ideas about the world found in important works of art.

Q: Should I demonstrate for my students?

By all means! If you can demonstrate how David Levine uses cross-hatching, how Delacroix draws a leg, how Lautrec's horses look from behind, then you should. The important thing is to provide students with many options, not just one, and if this is done, there is little reason to believe that students' personal styles will be inhibited.

However, when unable to provide a satisfactory graphic model or adequately demonstrate something, then show the student a drawing by another artist. The most important contribution to the development of drawing ability is the graphic model. If the teacher is able to provide a variety of illustrations of graphic images, techniques and processes fitted precisely to particular needs of a class or an individual student, what could be better?

There are outstanding drawing teachers who rely heavily on demonstrations. Betty Edwards says, "I recommend using the chalkboard as much as possible—not just to write words but also to draw pictures, diagrams, illustrations and patterns. Ideally, all information should be presented in at least two modes: verbal and pictographic." And Frank Bevan, who taught a popular course in costume design at the Yale School of Drama, drew as he spoke. He kept his blackboard covered with action drawings demonstrating dozens of details of the structures of costumes. One reason he gave for using what he termed his "parallel language" was that, because his students were not artists, they needed as much visual reinforcement as possible. He admitted, however, that in the early years of teaching it required practice before he was able to draw at the same rate as he spoke.

Q: How should students' drawings be graded? Isn't grading of students' drawings especially difficult when you emphasize re-creation rather than creation?

Grading students' work is problematic under any circumstances, but it is probably no more problematic when re-creation rather than creation is emphasized. In grading any project pay attention to these four factors: (1) the extent to which the students' drawings indicate an understanding of the theme, idea, expressive quality, style, etc. that might have been the focus of the lesson; (2) the aesthetic qualities and merits of the drawing; (3) the extent to which the student has trans-

formed the assignment into an individual and personal task; and (4) the amount of individual effort that has been devoted to the project. Although we think that drawing in the schools should be a form of criticism, the student drawings that exhibit the most sensitive attention to aesthetic features and individual and imaginative interpretations of the assignment are also evidence of the greatest amount of valuable art learning.

Q: Students always want to draw their pictures in pencil before using felt pens, ink, or watercolor. Should I permit them to do this?

Almost any way that a student chooses to use media can have some constructive purpose. Nevertheless, it is the teacher's responsibility to explain what is at stake in such decisions. Putting ideas down in pencil first creates a different kind of picture than going directly to a wet medium or a felt pen. We have seen stacks of sensitive pencil drawings that have been turned into clumsy felt pen drawings.

We recommend using at least two approaches: at times work *loosely and lightly* with pencil to set the stage for a drawing in another medium; but more often go directly to the committed line of pen and ink, felt pen, stick and ink or brush and ink. Certainly, because it is easy to erase and therefore less risky, using pencil makes students feel secure; but with practice in drawing and in the direct use of other media, students will steadily gain confidence in their own productions.

Finally, encourage students to make several small preparatory sketches in whatever medium they have selected before going to the final drawing.

Q: My students are constantly erasing. Is this good practice?

It certainly is not good for the paper. Constant erasing is frequently a sign of insecurity or of the search for the perfect line—a line that the student may never achieve. Help students see that corrections may often be made by adding another line rather than erasing. The record left by several lines during the search for the "right" line may actually result in a very successful drawing. The "perfect" line can always be pursued in future drawings.

Q: I'm sometimes tempted to help students by drawing on their drawings. Should I?

Don't rule out the practice of placing an occasional light line on a student's drawing. It is preferable, however, to draw on another sheet of paper or on the board. A teacher should seldom, if ever, say to a student, "Oh, you know how to do it," or "You know what a horse looks like." Drawing frequently depends on receiving adequate information about the things one attempts to draw and on translating that information into techniques and graphic programs. The teacher should provide the student with information about both images and processes. Even gestures, a trip to the window, showing a photograph or the drawing of another artist can provide students with the information that they seek.

Q: My high school students don't place much value on imaginative problems. All they are interested in is drawing realistically. How can I get them to value this aspect of drawing?

Have you taken the time to justify the imaginative function of drawing by showing examples of the many drawings that fit into this classification? (Surrealism, illustration, political cartoons, advertising, the absurd.) In the age of photography, video and cinema which make visually realistic images so easy to achieve, perhaps it is the imaginative and inventive aspects of drawing that are most justifiable.

Q: Students keep reverting to smiley faces, monsters, comic strip characters and other cultural stereotypes. How do I discourage this?

Should you discourage this type of imagery? Some of the popular cultural images such as monsters and superheroes are meaningful to students, and perhaps they should have a place in their drawings. We seldom prohibit their inclusion in drawings. But, they seldom find their way into the drawings that students produce in our classes because of the kinds of drawing exercises and assignments we give. Popular images appear most frequently when students are invited to draw anything they would like. We accept and even encourage the production of imagery from the mass media in students' spontaneous outside-of-class drawings. But in art class we prefer to work from images derived from the world of the fine arts. And, as you know, students will produce almost anything you invite them to.

Q: We have been taught that students should be provided with large sheets of paper and encouraged to work large. What do you think?

Students ought to have experiences working large, small and in many sizes in between. When it comes to drawing, however, we see far too many large drawings that should have been small but few small ones that should have been large. There needs to be a satisfactory "fit" between the size of the paper and the mark. For example, when the student is working with fine-pointed tools such as pencils, pens and thin-tipped felt pens, the format should be reasonably small. You will find, too, that when students work within small formats, their compositions will be tighter and the images will not appear either to "fall" along the bottom of the paper or get "lost" in the center. Also, consider the diminutive size of some of the master drawings that you see in museums. Imagine what gems we would have missed if the masters had used large-sized paper.

Q: At what age do you suggest teaching students techniques like cross-hatching and shading and things like perspective?

Young students are more interested in the ideas presented through their drawings than they are in the aesthetic and expressive qualities. Still the job of the teacher is to expand the students' conceptions of drawing possibility. Present young students with problems that will encourage them to ask how to alter the expressive qualities of their drawings. We can then say, "Have you thought of doing it this way?" In short, some teaching of technique and even perspective (simple prin-

ciples such as overlap, diminution and placement—higher or lower—on the picture plane) is appropriate even for the youngest students.

Q: Should I make suggestions to my elementary grade students about how they might improve their drawings?

Of course! But with a word of caution: we all know of the devastating effects of negative criticism, and generally it is best avoided. Still, if an elementary of secondary student is capable of performing at a higher level, or if they might benefit from a suggestion, then certainly make that suggestion—in the most positive manner possible.

Q: Why do you say so little about drawing materials and techniques?

In the past so many other art educators have said so much about them. Processes that achieve certain effects in drawing are important but they are only a means to some other end. Teachers should concentrate on the major purposes of drawing (having to do with the creation of meaning) and suggest the use of certain materials, techniques and processes primarily to make drawings more meaningful.

Q: You emphasize working from art, but isn't your method of teaching just copying from art?

It could become that. To eliminate the possibility of slavish copying, we emphasize that students should work from ideas that are similar to those of artists; but we hope that, in time and with practice, students will translate those ideas into something of their own. It is obvious to most artists, however, that copying is an effective learning tool. David Hockney has this to say on the subject:

> Copying is a first-rate way to learn to look because it is looking through somebody else's eyes, at the way that person saw something and ordered it around on paper. In copying, you are copying the way people made their marks, the way they felt, and it has been confirmed as a very good way to learn by the amount of copying that wonderful artists have done. About twenty years ago the idea of copying was completely abandoned in art education in Britain; it was not suggested at all, even as a way of learning. Somehow painting and drawing had become about personal expression, almost a therapeutic way of expression that made them perhaps go too inward, losing feelings of the ordinary things about them. But of course we all do copy anyway. Most art students at work today are copying, even if it is in rather an indirect way.

It should be noted that Hockney assumes that the subject of a copy is worth the trouble; that to copy a second-rate illustration is not at all the same as working from one by Cassatt or Delacroix.

Notes

7. The quote from Edna Shapiro is from "Copying and inventing: similarities and contrasts in process and performance," in *Symbolic Functioning in Childhood* (N. Smith & M. Franklin, eds.). Hillsdale, N.J.: Earlbaum, 1979.

9. This quotation by John Berger comes from his book, *The Success and Failure of Picasso*. N.Y.: Pantheon Books, 1965.

12. The ideas of worldmaking are derived from Nelson Goodman's *Ways of Worldmaking*. Indianapolis, Indiana: Hackett, 1978.

12. The idea of centering art production on the ordinary everyday experiences of the child is attributed primarily to Viktor Lowenfeld. Lowenfeld, V. *Creative and Mental Growth* (3rd ed.). N.Y.: Macmillan, 1957.

14. Nelson Goodman. *Ways of Worldmaking*, pp. 1–22.

14,

15. The story of Onfim is recounted in *School Arts* (March 1985), Vol. 84, 7.

15. For a more complete development of these ideas the reader is referred to Wilson, M. & Wilson, B. *Teaching Children to Draw*. Englewood Cliffs: Prentice-Hall, 1982.

17. The conversation with Ernst Gombrich is in Jonathan Miller's *States of Mind*. New York: Pantheon Books, 1983.

18. The idea of avoidance of overlap was developed in Jacqueline Goodnow's *Children Drawing*. Cambridge: Harvard University Press, 1977.

19. For a further explication of the "perpendicular principle," see Henry Schaeffer-Simmern, *The Unfolding of Artistic Activity*. Berkeley & Los Angeles: University of California Press, 1950; and Wilson, B. and Wilson, M. (1982), "The persistence of the perpendicular principle: why, when and where innate factors determine the nature of drawings." *Review of Research in Visual Arts Education* Vol. 15, pp. 1–18.

19. The principle of non-differentiation derives from Rudolf Arnheim, *Art and Visual Perception* Berkeley & Los Angeles: University of California Press, 1974.

19. Discussions of the principles of conservation, format conformation and intuitive balance may be found in Jacqueline Goodnow's *Children Drawing*.

21. Goodnow also writes of the principle of embellishment.

21. Intellectual Realism was conceived by the French philosopher and student of children's drawings, G. H. Luquet in his *Le Dessin Enfantin*. Paris: Alcan, 1927.

21. The concept of unfolding is to be found in Henry Schaeffer-Simmern's *The Unfolding of Artistic Activity*.

21. An example of a highly structured 19th century drawing text is Walter Smith, *Teacher's Manual of Free Hand Drawing and Designing and Guide to Self-Instruction*. Boston: Rand, Avery & Co., 1873.

22. David Feldman in his book, *Beyond Universals in Cognitive Development* Norwood, N.J.: Ablex, 1980, puts forth the idea of small changes instead of a few stages of development.

22. For a description of the child's movement in drawing from tadpole to full figure, see Wilson, M. & Wilson B. *Teaching Children to Draw*.

22. Most accounts of drawing development, e.g., Lowenfeld and Schaeffer-Simmern, describe regular, almost predictable increases in the complexity of drawings. Luquet was the first to talk about *fortuitous discovery*.

22. In *Art and Visual Perception*, Arnheim sees the concept of *differentiation* as a response to the desire for more complexity in drawings.

24. In *Art and Visual Perception*, Arnheim speaks of the child's creation of "graphic equivalents." Non-intereference with the child's natural process of unfolding is seen in the accounts of Franz Cizek, of Schaeffer-Simmern and Lowenfeld.

24. A more complete account of the drawing activities of the children in the Egyptian village of Nahia can be found in Wilson, B. & Wilson, M., "Children's drawings in Egypt: cultural style acquisition as graphic development." *Visual Arts Research*, Vol. 10, 1.

27. Wilson and Wilson have written about the role of individual characteristics and abilities in more detail in *Teaching Children to Draw*.

33. Robert Kaupelis taught art at New York University and is the author of *Learning to Draw*, N.Y.: Watson-Guptill, 1966, and *Experimental Drawing*, 1980.

33. "Taking a walk with a line" is a paraphrase of Klee's opening statement in his *Pedagogical Sketchbook* (N.Y.: Praeger, 1960) in which he writes of a drawing as "an active line on a walk" (p. 16).

33. The exhibition referred to here took place at the Maryland Institute, College of Art (MICA).

34. Daniel Mendelowitz' book on drawing is the third edition of his *Guide to Drawing* revised by Duane A. Wohlham. N.Y.: Holt, Rinehart & Winston, 1982.

37. The idea of "essentially contested concepts" such as drawing can be found in Morris Weitz's "The nature of art." Eisner, E. & Ecker, D. *Readings in Art Education*. Waltham, Mass.: Blaisdell, 1966.

43. John Gardner discusses the necessity of using the novels (we can substitute art) of the finest writers (artists) as models in *The Art of Fiction*. Alfred A. Knopf, 1984, p. 11.

61. John Gardner continues to speak of "the great masters who, properly understood, provide the highest models yet achieved by our civilization." *The Art of Fiction*, p. 12.

85. Kimon Nicolaides wrote the popular book on the teaching of drawing, *The Natural Way to Draw*. Houghton-Mifflin Co., 1941.

94, 95. The teacher whose imaginative still life displays we have gratefully reproduced here is Wilma Pincus, The High School of Art and Commerce, Ottawa.

101. Keith Gentle. "Learning through drawing," in *Drawing for Schools: A Conference,* the proceedings of a drawing conference directed by Al Hurwitz, Maryland Institute, College of Art, 1983, p. 21.

107. Henry R. Poore. *Pictorial Composition and the Critical Judgment of Pictures* (13 ed., revised). N.Y. & London: G. P. Putnam, 1903.

117. Degas was quoted in Lecoq de Boisbaudran's *The Training of the Memory in Art and the Education of the Artist* (trans. L. D. Luard). London: Macmillan, 1914, introduction p. xxxii.

120. Madame Cavé's *Drawing from Memory* was translated from the French edition and published in New York and London by G. P. Putnam, 1886.

120. Thomas Malton. *Treatise on Perspective.* 1783.

122. *Memories of James MacNeil Whistler* was written by T. R. Way.

127. The data from the National Assessment of Educational Progress art exercise, 4 people seated at a table, are to be found in *Art Technical Report: Exercise Volume* (1978) by the National Assessment of Educational Progress, Education Commission of the States, Denver, Colorado, pp. 147–155.

143. Leonardo's quotation is from James Beck's *Leonardo's Rules of Painting* N.Y.: Viking Press, 1979, p. 57.

143. The National Assessment of Educational Progress exercise, running figure is in *Art Technical Report: Exercise Volume* (1978). pp. 162–167.

150. The data for the National Assessment exercise "Angry Person" are reported in *Art and Young Americans, 1974–79: Results from the Second National Assessment* (1981) by the National Assessment of Educational Progress, Education Commission of the States, Denver, Colorado, pp. 74–76.

150. N. Whittock. *The Oxford Drawing Book,* 1825.

151. Leonardo's descriptions of "The Battle of Anghiari" are in Pamela Taylor's *The Notebooks of Leonardo DaVinci.* New American Library of World Literature, 1960.

153. For the definitive study of Picasso's sketches for *Guernica* see Arnheim, R. *Picasso's Guernica: The Genesis of a Painting.* Berkeley & Los Angeles: University of California Press, 1962.

154. The series of Rembrandt etchings of 1630 are chronicled in *The World of Rembrandt.* N.Y.: Time-Life Books, 1968.

156. Manga, the Japanese comics are detailed in Frederick L. Schodt's *Manga! Manga! The World of Japanese Comics.* Tokyo, N.Y. & San Francisco: Kodansha International, 1983.

159. The Leonardo quote is in P. Taylor's *The Notebooks of Leonardo DaVinci.*

160. Earl Barnes' study from "Johnny Look-in-the-Air" is in his "A study on children's drawings." *Pedagogical Seminary* Vol. II, 1892.

160. Children's illustrations of "Johnny Look-in-the-Air" are in Lou Eleanor Colby's *Talks on Drawing, Painting, Making, Decorating for Primary Teachers.* Chicago: Scott, Foresman, 1909.

164. In his book, *Art and Education* (London: B. T. Batsford, Ltd., 1968, p. 38.), Michael Stevani describes the methods used by Marion Richardson

"to stimulate the imaginative powers of . . . children by the use of words."

170. Richard de Mille's imaginative and imagination-stretching games are written in *Put Your Mother on the Ceiling*. Penguin Books, 1967.

171. Italo Calvino is a writer whose descriptions contain such fanciful and fantastic verbal imagery that they lend themselves naturally to graphic imagery. The description of plumbing was adapted from "Thin Cities 3," the city of "Armilla" in *Invisible Cities*. New York: Harcourt Brace Javonavich, 1974, p. 51.

175. Accounts of verbal descriptions by Cizek as well as actual dialogues with children are recounted in William Viola's book *Child Art*. London: University of London Press, 1942.

177. Willem de Kooning's views on art and abstraction were heard at a symposium held on February 5, 1951, at the Museum of Modern Art in New York City. From *What Abstract Art Means to Me, Bulletin of the Museum of Modern Art*, XVIII, 3 (Spring, 1951).

190. Betty Edwards. *Drawing on the Right Side of the Brain* Los Angeles: J. P. Tarcher, 1979, p. 197.

193. Hockney on copying is found in the introduction to Jeffrey Camp's *The Drawing Book* N.Y.: Holt, Rinehart & Winston, 1986.

Index